THE ESKIMO
AND HIS
ART

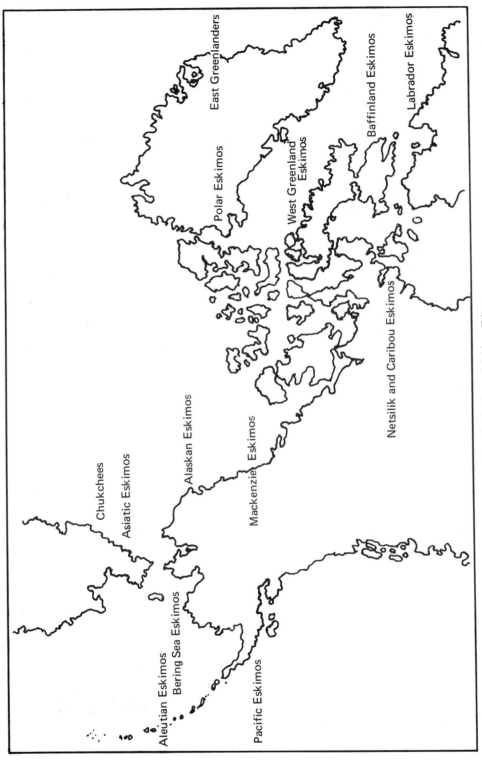

The Distribution of Eskimo Tribes

THE ESKIMO AND HIS ART

Carson I. A. Ritchie

Academy Editions · London

St. Martin's Press · New York

First published in Great Britain in 1975 by
Academy Editions 7 Holland Street, London W8

SBN 85670 014 2

First published in the U.S.A. in 1975 by
St. Martin's Press Inc., 175 Fifth Avenue,
New York, N.Y. 10010

Library of Congress Catalog Card Number 73—93022

Reproduced and printed by photolithography and bound in
Great Britain at The Pitman Press, Bath

Contents

Acknowledgements

I should like to thank the following photographers, museums and institutions for assisting me with the photographs for this book: Stella Mayes Reid and Bernadine Bailey; British Museum, London; National Maritime Museum, Greenwich; Museum für Völkerskunde, Munich; the Hugh Moss Gallery, Lippel Gallery Inc., Canadian Arctic Producers Ltd, the Danish Tourist Board and Sotheby and Co.

Foreword:
then
and now

Many of the statements in this book have perforce to be put in the past tense. The Eskimo way of life has changed so much even in the last fifty years that there is little described in the following pages, except for modern art, which does not belong to a way of life which is now ancient history as far as most Eskimos are concerned.

The traveller who pauses for a moment outside the supermarket at Narssaq, thankful that he has escaped being run down by the youthful motor cyclists who career up and down the dirt roads will see little to convince him that he is not still in Denmark, Iceland, or the Faeroes. Only the hair styles of the Eskimo women and their brightly patterned blouses in traditional style seem in any way reminiscent of the world of Eskimo Art with which he has familiarised himself in museums, and in the pages of books.

Though there are parts of the vast territory which Eskimos inhabit which are much nearer to traditional Eskimo culture than Greenland or Alaska (Arctic Canada is one of them) it ought not to be forgotten that the finest works of Eskimo art arose in conjunction with quite a complex social and religious life which no longer exists anywhere and which can never be revived.

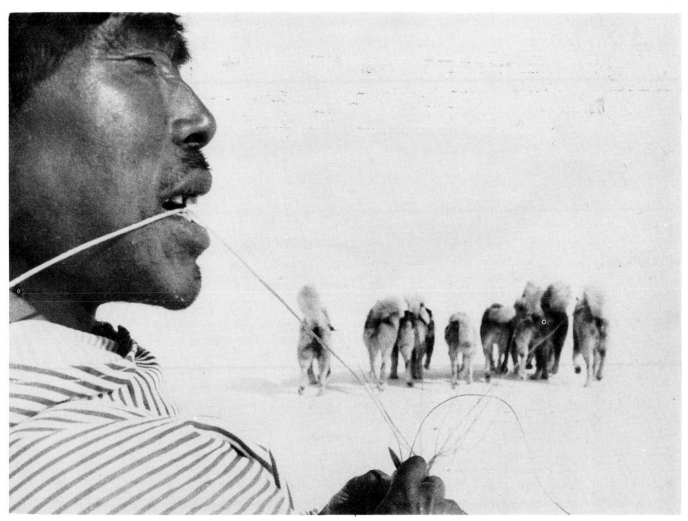

1 Greenland Eskimo today (Photo Danish Tourist Board)

The Eskimo: historical background

The ancestors of the present day Eskimos originated in Siberia; 15,000 years ago, they passed across the land bridge which then spanned the Bering Straits into Alaska. They spread east and north-east, reaching Northern Baffin Land in Canada and pushing further on into Greenland, where they arrived some 4,500 years ago.

An important Eskimo civilisation began to evolve in Baffin Land, associated with the Dorset People, but the Bering Straits remained the heartland of Eskimo culture. Here, at Okvik, appeared the first of the Old Bering Sea People. They lived in permanent earth dwellings, and an abundance of good food stimulated artistic production. They engraved ivory and bone in sinuous curves and circles.

A later branch of the Old Bering Sea People, who lived at Ipiutak, near Point Hope, developed an art with strong Asiatic influences. A cult of the dead necessitated beautifully fashioned, but impracticable harpoons, which were buried with the dead, and masks, while the corpses were laid out with fittings of ivory and jet. Many Ipiutak carvings relate closely to the Scythian animal art and the archaic bronzes of China.

A later branch of the Old Bering Sea People, the Punuks, developed some of the traditional patterns of Eskimo art, including the spot and circle pattern.

The Dorset People, who had evolved about 2,700 years ago in Baffin Land, spread widely across the Arctic from Newfoundland (which they reached about 2,000 years ago) to East Greenland. They invented the *igloo* or snow house, and the woman's crescent shaped knife; they wore long cloaks with high collars, which are represented in their ivory carvings. Many of their art forms are not so very different from those made today, or until quite recently. One of their designs which has persisted to our own day, is a carving of multiple masks or faces, ranged one above another.

To the Dorset succeed the Thule People. Thule life and art had developed in isolation in Southwest Alaska. Suddenly, during the tenth century AD, they began to spread over the whole of the Arctic, moving from Canada to North Greenland and thence to West and East Greenland. The last waves consolidated their hold on the Canadian Arctic.

The Thule people, who presumably wiped out the Dorsets, had invented the *umiak* and the *kayak,* large and small skin boats. With the Thule, modern Eskimo art really appears. Their art products contained such significant items as shamanistic equipment, scrimshawed hunting scenes, wooden figurines, decorated needle cases, ivory snow goggles and papoose cradles. The Thules impressed a very homogeneous culture on the whole of the Arctic, which however, allowed substantial regional variations, between Alaskan and Aleut Eskimos, and even between East and West Greenland.

Congruity of culture was forced on the Eskimos by the similarity of the territory they inhabited. Only in the Aleutian islands did the climate become less than polar. Snow-covered ice, frozen tundra, and inhospitable rocks and mountains compelled the 'People', as they called themselves, to be hunters and fishers rather than agriculturists. They remained dependent for transport on dog-pulled sledges and large and small skin boats. Sea mammals such as walrus, seal, and whale, formed their staples and ensured that most of them lived very close to the sea.

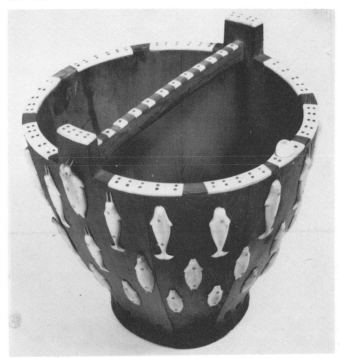

2 Water bucket with ivory cutouts. The cutouts represent seals and a walrus at the top, and *tornassuk,* a mythical creature, at the bottom (Photo British Museum)

Physically all Eskimos were very alike. They were short, with dark brown eyes, and black hair, straight and rather tousled. The girls are often very pretty in a Japanese style, the men look vivacious, good natured, and frank, as

3 Mask of ivory and jet, Ipiutak culture

Captain Cook remarked in 1776. The legs of the men were often bowed through the constriction of the kayak. Both sexes were sturdy, and capable of great mental and physical endurance. They had a greater resistance to cold than do Europeans, and their Mongolian phlegm enabled them to confront, unmoved, the myriad perils of the environment in which they lived. Their cheerfulness has often been commented on, and much of their art is the expression of their bubbling sense of fun and enjoyment of life.

It was ironical that it was on the most developed artistic centres of the Eskimos — Greenland and Alaska — that the blight of European colonisation fell most heavily. Contact between the white and Eskimo races had begun when the Norsemen made a settlement in Greenland in the year 985 AD. The descendants of the original settlers retained a precarious hold on the eastern seaboard until the fifteenth century. By that time Greenland had, like the mother country Iceland, become a vassal of the Norwegian king. Extremely severe laws prohibited the Greenlanders from building their own ships, or trading with any ship save one that had a royal licence, issued in the King's port of Bergen. The Black Death in Norway, and the destruction of Bergen by the Germans, completed the ruin of the Greenlanders. The settlement disappears from history. Cut off from supplies of essential cereals from Europe, the colonists must have perished from famine or disease. Massacre at the hands of the Thule People is another possible alternative.

Claims have been made that the Greenland Eskimos were affected by Norse art. Carved wooden figures have been confidently pointed to as displaying 'European faces'.

It is true that the faces in question have no resemblance to an Eskimo — but that is because the Eskimo cannot carve Mongolian noses. There are plenty of other carved faces with prominent noses, distributed throughout the other Eskimo cultures.

It is much more likely that Viking costume may have had some effect on the Eskimos. There is a story that one Bjorn Einarsson, an Icelander who spent two years in Iceland between 1385 and 1387, employed as a servant an Eskimo girl whom he had rescued from drowning. The girl wanted a headdress just like Einarsson's wife, Solveig. She could not get any fabric material to make it from, so she sewed one from whale's intestines! Possibly the Eskimo hood and parka are connected with European mediaeval costume, as worn in Greenland.

Another influence may possibly be traced in the use by the Eskimos of skin boats, *kayaks* and *umiaks*. It seems a remarkable coincidence that skin boats of this sort, called *curraghs,* should have been used by the Celtic missionaries who penetrated to the far north, and independently invented by the Thule people. Just a year or so ago I was standing by the ashes of a fire which had been excavated in the very centre of Reykjavik, the Icelandic capital. This fire had been lit by someone who had come to Iceland at least a century before the Vikings landed there. He was probably a Celtic missionary, like St. Brendan — perhaps even St. Brendan himself.

Long before the last of the Greenlanders was laid to rest in the Cathedral of Brattahlid, Europe had forgotten about Greenland, and with it the Greenland Eskimos. But in 1721 a pertinacious Danish clergyman called Hans Egede pestered the Danish crown to send out an exploration party to look for the lost settlement. He never found it, but he set up a Danish colony in Greenland, at Godthab. Although the King later changed his mind about colonisation, and ordered a withdrawal of the settlers, Egede, his wife Gertrud, and a few others stayed. When a relief ship finally arrived in 1733 it brought not merely Moravian missionaries who were bitterly opposed to Egede, but smallpox, which killed off most of the population, including Gertrud.

Thenceforth, troubles multiplied for the Greenland Eskimos. Christianity, preached with a cudgel, had undermined the belief in the shamans who had directed the community and used many of its art products. With the abandonment of the old religion, many objects associated with it — such as shaman's masks and idols — ceased to be made. Worse still, the whole economy of the Eskimo became so undermined that they could no longer scrape a livelihood, much less find time for art production. The introduction of firearms wrought a holocaust among animals and birds. By the late nineteenth century it was impossible to find enough skins to cover an *umiak*. The furs and pelts which were indispensible for clothing and boats had been bartered to provide luxuries which the Eskimos had never known before the white men came and

which they could not afford. The time taken off for schooling had distracted the Eskimos from their main business in life, handling a *kayak,* so that fatal accidents at sea became more and more frequent. European epidemic

4 Head in ivory, Punuk culture

diseases and drink thinned out the population that famine had spared.

Meanwhile the Alaskans had fared even worse. Three voyages made by Vitus Bering, a Danish explorer in Russian service, between 1728 and 1741, had revealed the Alaskan coast and the Aleutian islands. The survivors of Bering's last voyage had brought back with them a cargo of sea-otter pelts and other furs worth millions in our money.

As the news of the discovery of this fur eldorado spread throughout Russia small bands of rascally *promyshlenniki,* the equivalent of the Canadian *coureurs du bois* built themselves boats of bone, and sailed to Aleutia. In 1764 the Russian government conceded the monopoly of fur collection in the archipelago to a company called the 'Siberian American Company'. The Company was allowed to enlist soldiers, construct forts, and tax the inhabitants. The Czar would take ten per cent of the profits, the

shareholders could keep the rest. The company began by ordering half the proceeds of the chase to be handed over to them. For the next forty years they ravaged the archipelago, enslaving the Aleuts, forcing them to put to sea in all weathers to catch seals, and keeping their wives and families as hostages for their return. Half the male

5 Figure from Dorset Culture, Thule, Greenland. Note the 'skeletonised' figure and the high collar of the prehooded *parka*

Aleut population between the ages of eighteen and fifty spent their entire year in hunting for the Company.

In 1784 the first Russian colony in Alaska was established, at Three Saints Bay, on Kodiak Island. Russian

11

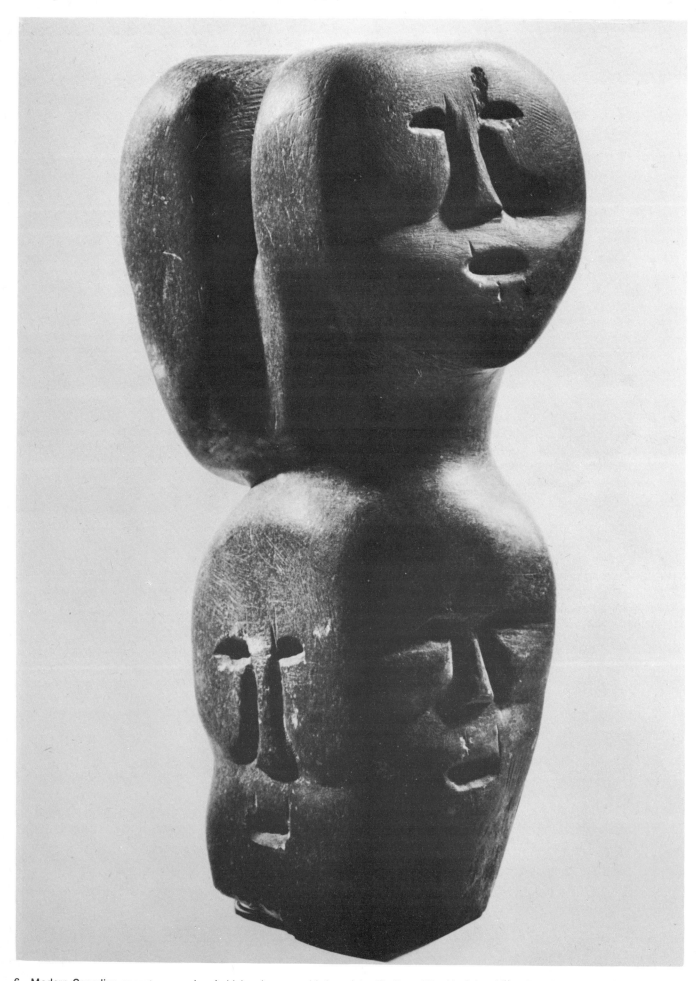

6 Modern Canadian soapstone carving (which echoes an old theme) by Tic Tac of Rankin Inlet. (Canadian Arctic Producers Ltd)

expansion followed as the Russians attempted to secure the monopoly of the fur trade. Large contingents of Aleuts were drafted to the mainland, and even to distant California, to hunt on behalf of their tyrannical masters.

By the middle of the nineteenth century the fur business no longer paid its way. So many fur-bearing seals had been killed that in just one year, 1,803,800,000 skins were stockpiled. As they could no longer command an instant sale, owing to the market being glutted, they were burned.

In 1867 Alaska was sold to the United States. Russian occupation had reduced a numerous, vigorous, and laughter-loving race to a mere handful of debased and down-trodden serfs. Only about 2,000 out of an original population of possibly 25,000 had survived. Most of those whom remained had been mongrelised by the Russians, and almost all had become converts to Christianity, because conversion meant tax-relief for three years.

'By losing all confidence in themselves,' wrote a nineteenth century observer, 'they lost all pleasure in living, and even their natural disposition. There were no more joy and gaiety, no more songs and dances, no more grotesque and comic fancies.'

In Canada the relationship between whites and Eskimos has not always been easy, nor have the latter been spared, in any degree, the myriad evils that civilisation brings to an undeveloped people. Nevertheless the course of Eskimo life has run very differently. Unlike the *promyshlenniki,* the Scottish-Canadian fur trader who worked for the Hudson Bay Company was more of a friend and mentor than an exploiting middleman. Lord Strathcona, the High Commissioner for Canada who began life as a fur-trader with the Company, saved so many Eskimos from dying during scarlet fever and diphtheria epidemics that fifty years later he was invited to lecture at the Middlesex Hospital in London on how he had adapted local methods to the treatment of these diseases.

The best proof that things were ordered better in Canada is to be found in the resurgence of Eskimo art. From being thought a backward people, artistically, the Canadian Eskimo has now become the centre of Eskimo art throughout the Arctic.

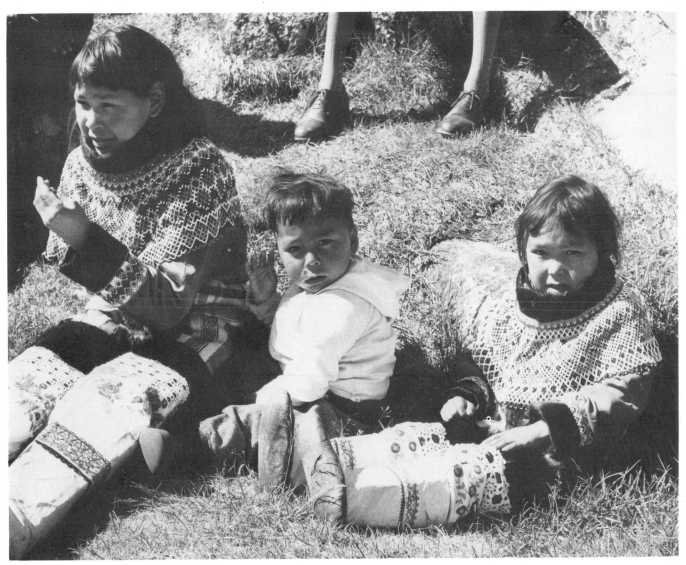

7 Modern Greenland children's costume, with embroidered skin boots and cloth parkas ornamented with beading (Photo Danish Tourist Board)

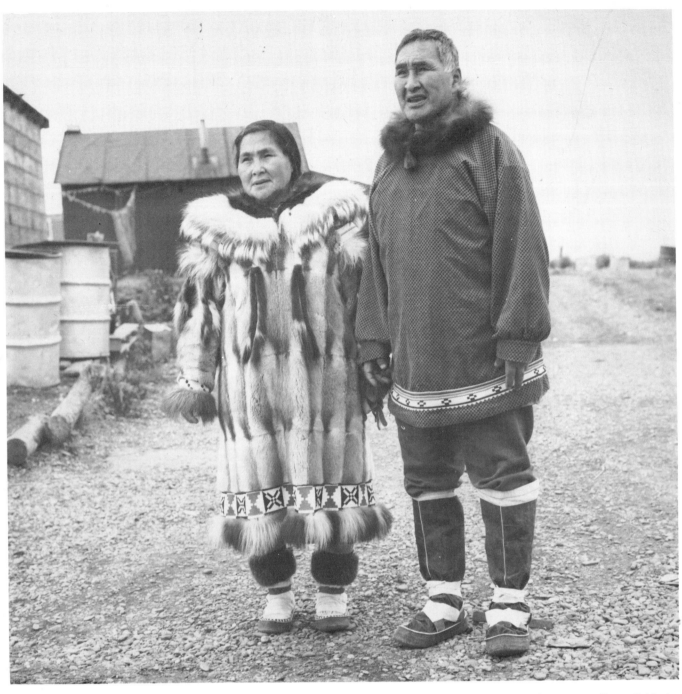

8 Modern Alaskan costume at Kotzebue. This is much nearer to the original Eskimo costume because furs are readily available in Alaska (Photo Bernadine Bailey)

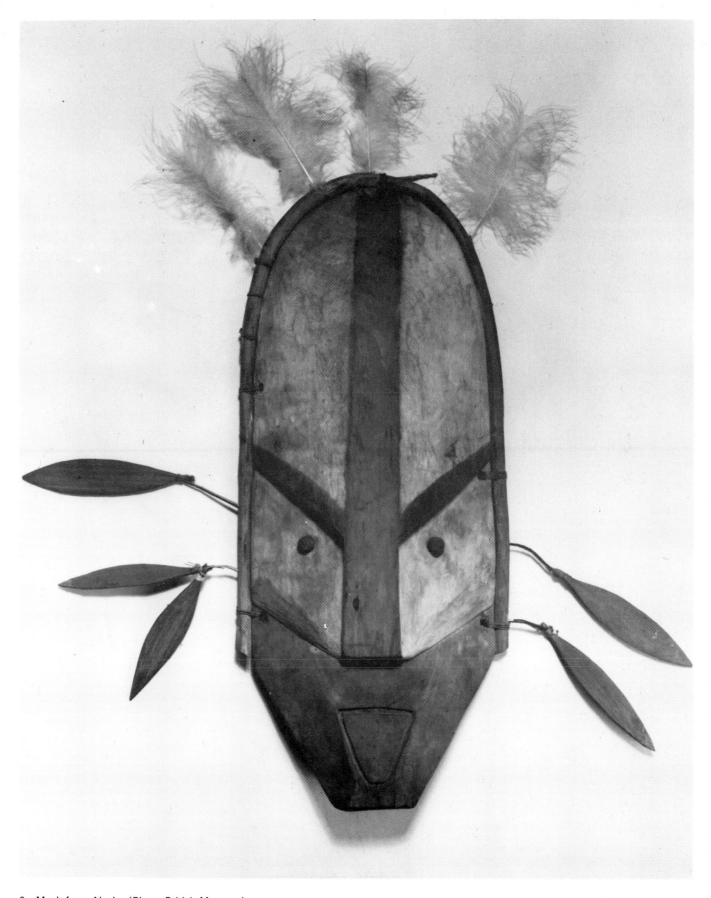

9 Mask from Alaska (Photo British Museum)

Travel

Originally the Eskimos had no alphabet, or other form of writing, though they have now developed their own distinctive alphabet under Canadian influence, and it appears in many of their modern prints.

There were various substitutes for the written word. 'Story knives', from the central Bering Sea coast, may have served as mnemonics. Scrimshawed scenes of hunting, or the same themes painted on window panes of gut, may not have been random ornamentation, but rather a precise record of the chase.

The *kayak* was a cooperative effort between a man and his wife. The husband constructed the wooden framework, the wife, helped by the other women of the village, fitted and sewed the skins which covered the hull. The framework was made up from driftwood, usually a light white wood, to which pieces of osier had been fitted as ribs. It was lashed together with sinews, no nails or pegs being used. In Greenland the skin covering was made from saddle-back seals or bladder-nosed seal skins. *Kayaks* were tailored individually to suit the possessor, like a *parka*.

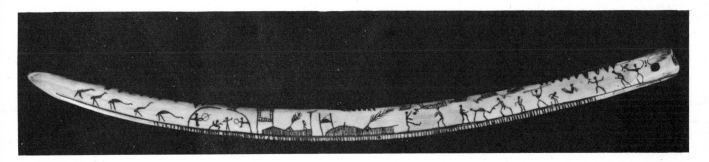

10 Walrus ivory bow drill from Alaska, with scrimshawed figures of men drumming in a drum house, playing ball games and dancing (Sotheby and Co)

The layout of the sea coast, a matter of supreme importance to seafarers, was recorded by means of wooden maps. These ingeniously combined not merely the shape of the coast, but also the countour of the hills, which would act as seamarks to a voyager in a *kayak*.

Two kinds of maps were in use. One was a block map, on which the coast and islands stood up in relief on a flat background. The other was a stick map, in which the relief of the coast was seen as a notched outline. The coastline began on one side of the stick, and finished on the other, the islands showing as protuberances standing out from the stick. Maps of this sort recorded all the information necessary to the hunter: the places where narwhals and seal abounded, portages across fiords, and the ruins of old houses, which would mark a spot on the coast where it was easy to beach a *kayak*.

The Eskimo can claim to have made one invention which has spread right over the modern world, the *kayak*. The handiness of this one-man craft can be seen from the fact that it is still in use in the Arctic, alongside other kinds of sea-going boats.

Once the skin covering had been shrunk on, the owner fitted bone or ivory knobs to the stem and stern, an ivory or bone false keel, and bone buttons and thongs to fasten down equipment on to the deck. The line runner, a piece of equipment which regulated the action of the harpoon line, was often so highly ornamented with ivory cut-outs that it looked like a little shrine. On the deck of the *kayak* would be stored the harpoon, the harpoon line, the harpoon bladder, the lance, the *kayak* knife, the bladder dart, the bird dart, and the spear thrower. The paddle, like every other part of the *kayak,* might be ornamented and edged with ivory supports.

Different types of *kayak* appeared in different parts of Eskimo territory. There were two-men *kayaks* in the Aleutians for example. Nevertheless the *kayak* did not change much over the years. One collected in the seventeenth century, and now in Edinburgh, shows little difference from those in which modern East Greenlanders still make journeys, only the covering is less often sealskin nowadays than canvas, a fact which may account for the increased number of fatalities in *kayak* sailing just as much as a falling off of the old skills in seamanship.

11 *Umiak*, the large 'woman's boat', drawn up on the beach in Alaska (Photo Bernadine Bailey)

Compared with the *kayak,* the *umiak* or woman's boat was a much less adventurous affair. It was more stable, and it was constructed of quite substantial timbers, covered with a hide sheathing. It could carry a sail, made from seal intestines, which helped it to make much better speed than a *kayak.* Moreover it could carry quite a large crew. Three or four women rowed each of the two oars which propelled the *umiak.* Just because it was so much safer,

18

men despised it, and never entered it, except sometimes to steer, when there was a voyage of some importance, or when it carried a cargo of raiders in time of war.

The dog sled was ingeniously made from wood, ivory, whalebone, or caribou antlers, depending on what was available. Even frozen salmon could be built up into the runners of sledges, and the rolls of sealskin could be used for the same purpose. The most usual kind of sledge however was made of wood, with antler handles and bone or ivory plating on the runners. Runners were always given an additional covering of ice, so that sledges underwent hardly any wear and tear. A team, headed by a lead dog, was fastened to the sledge by thongs held together with ivory harness clasps, often carved with supreme artistry.

The Eskimo huskie dog was just as much a hero of the Arctic as the Eskimo himself. He was ferocious to the point of cannibalism, yet so attached to his master that if sold away from the team he would make long journeys back to join him. Spirited enough to bring a polar bear or a musk ox to bay, he would put up with incredible hardships without flinching.

Snowshoes may have been an Eskimo or an Indian invention. They are widely used by both people, and are just another invention, made in the Arctic, which has made life easier for people in cold climates all over the world.

12 Stony knife from Bering Sea Coast, Alaska

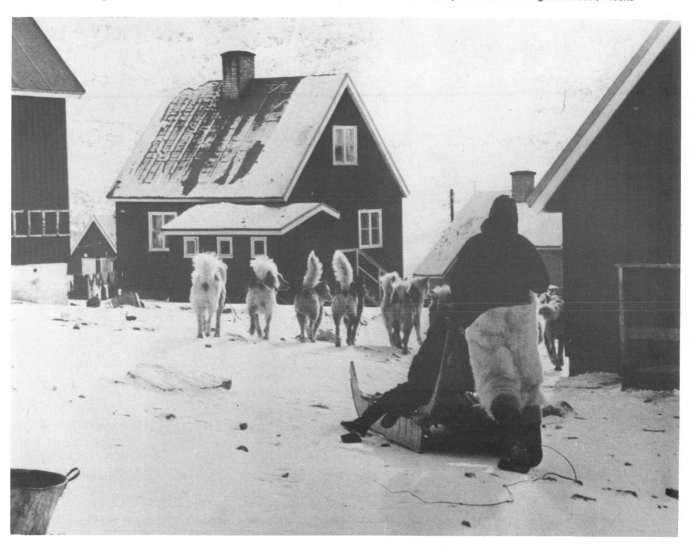

13 Eskimo dog sledge (Photo Danish Tourist Board)

The Eskimo at home

Whether a rude snow shelter built round a hunter as he sat patiently beside the breathing hole of a seal, his knees bound together for fear he should move and disturb the game, or a regular *igloo*, built from blocks of snow quarried with an ivory knife inside three hours; whether a permanent winter home, painstakingly constructed from piled up stones, whale's ribs, and hides, or an underground *barabara*, a light summer tent, which could be folded and carried, or even an inaccessible cliffside dwelling at the edge of the Bering Sea which could serve as a fortress it attacked, the homes of the villagers were perfectly adequate, and completely functional. They were, of course, adequate only by Eskimo standards. Europeans never ceased to marvel at how in Greenland a man with two wives and seven children would occupy a partitioned space in a winter house measuring six feet six inches by four feet. No European could have occupied such cramped quarters, nor would he have wished to. Dogs occupied the entrance to every Eskimo home, bitches shared the beds. There were faeces everywhere. Privacy was unknown. The villagers urinated into the urine buckets where the precious liquid which was used for soap and many other purposes was stored. The villagers were also completely promiscuous. Hosts offered guests their wives, and if strangers visited the village it was customary to extinguish the lamps in the hut, so that no one could tell who slept with whom. Many of the festivals of the year were concerned with pairing off couples who were obliged to sleep with one another for the night of the ceremony.

So there was no feeling of individual family life, and cleanliness and attractiveness were sacrificed completely. All that was required of a home was warmth. The nomadic instinct of the Eskimo, together with the fact that houses were impermanent possessions, which might be abandoned for the use of the dead, prevented any kind of ornamentation or embellishment, at least in modern times.

The most permanent and most impressive of Eskimo buildings was the Alaskan *barabara*, a permanent earth house partly dug out of the earth, and partly built up with a timber framework over which turfs were laid. Cook has given a good, first-hand description of one of these houses:

Their method of building is as follows: They dig in the ground an oblong square pit, the length of which seldom exceeds fifty feet, and the breadth twenty; but in general the dimensions are smaller. Over this excavation they form the roof of wood, which the sea throws ashore. This roof is covered first with grass, and then with earth, so that the outward appearance is like a dunghill. In the middle of the roof, towards each end, is left a square opening, by which the light is admitted, one of these openings being for this purpose only, and the other being also used to go in and out by, with the help of a ladder. Round the sides and ends of the huts the families (for several are lodged together) have their separate apartments, where they sleep and sit at work, not upon benches, but in a kind of concave trench, which is dug all round the inside of the house, and covered with mats, so that this part is kept tolerably decent. But the middle of the house, which is common to all the families, is far otherwise; for, although it be covered with dry grass, it is a receptacle for dirt of every kind.

A Greenland winter house did not materially differ from Cook's description, except in plan. It was built on ground sloping down to the sea, and near to a good landing-place. The walls were partly excavated, and partly built up with loose stones. The roof ridge was built of stout driftwood, resting on props; it was covered with turfs, a layer of earth, and a layer of old skins.

A passage-way led into the house, breaking the force of the wind and serving as a kennel for the dogs. Light was admitted through windows of transparent intestines, two in the house and one in the passage-way. Inside were wooden platforms on which different families slept, with flimsy skin partitions between them. Much about Eskimo house-building recalls houses lived in by other members of the great Mongolian family. The Chinese dig a trench, and sit with their feet in it, if they want a quickly-constructed substitute for a table and chairs. The Japanese in remote times also slept on wooden platforms.

If some forms of housebuilding show resemblances to those in use in other parts of the world, the *igloo* is certainly unique. This instant snow house was principally in use in Arctic Canada. The builder dexterously cut and shaped curved blocks of deep fallen snow with an ivory snow-knife. Each block was so shaped that it fitted into the next in the tier, sloping inwards and curving sideways with such exactitude that the blocks, when fitted together, made up a perfect dome. A window of transparent ice and an entrance tunnel affording shelter from the wind and a kennel for the dogs completed the *igloo*. The walls could not be made too thick, otherwise they would start melting on the inside, causing water to drip on the inmates. It took constructional abilities of a very special sort to make a

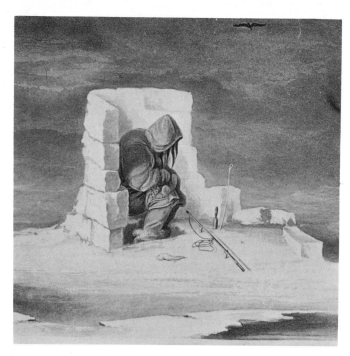

14 With a snow windbreak behind him and his knees lashed together lest a single fidget betray his presence, an Eskimo waits for a seal to rise to its breathing hole. When it does he will harpoon it through the tiny hole, enlarge the opening with his snow knife, which is placed ready, and drag his prey to the surface. Drawn in Canada by Lyon, 1821

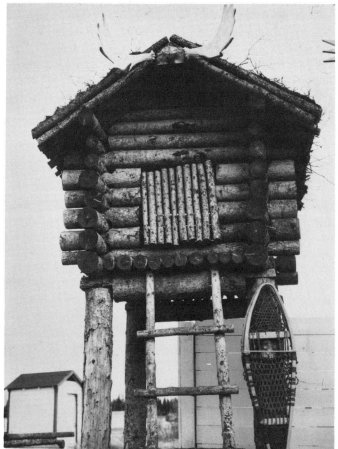

15 A cache for food made from logs in Alaska. Note the snowshoes propped against the supporting post (Photo Bernadine Bailey)

snow block with such exact requirements, and with no model or plan to go by. Eskimos however never seem to have required a plan to make anything. All their projects were constructed straight out of their heads, without even preliminary sketches. The same faculty of eidetic vision enabled Coodjissi, an Eskimo who was known to Hall, to draw an exact plan of Rescue Harbour in Arctic Canada. The Eskimos could not only envisage a segment of a perfect dome before they cut it out of the snow, they can also claim the credit of having invented the dome for themselves, independent of its invention by the Romans.

The summer houses of the villagers could have a dome shape, or be constructed rather like an Indian tepee. It was framed with willow branches, covered with bark, or made from more substantial materials, such as caribou skins, turfs, or brushwood. Tents, which either recalled the *yurts* of Central Asia by their dome shape or were cone-shaped, were also used in summer time.

Perhaps the most substantial buildings made in the Arctic were the stone caches which occur in Canada. These were constructed of pillars, so well trimmed and sorted into sizes that they recall prehistoric menhirs on a small scale. Capacious wooden caches, which are really small houses or storerooms in themselves, are still constructed from timber in Alaska.

Another exclusively Canadian construction was the caribou pillar, a human-shaped pile of stones erected on the coastline. Besides serving as a sea-mark, the caribou pillar acted as an automatic beater. Men and boys dodged

in and out between the pillars in sight of a caribou herd, and the short-sighted beasts imagined a large body of men was hanging on their flanks. Frightened, the caribou made off in the opposite direction, where hunters lay in wait for them with bows and arrows.

Singing houses and tombs, specialised types of buildings, are discussed elsewhere. Although, as has been already remarked, no artistic expression is to be found in houses, this need not have been always the case. Many of the unexplained ivory whorls and spirals of Ipiutak, for example, may have entered into house decoration. The double-spiralled ivory carvings, which are pierced for suspension, are rather similar to a toy of the Victorian age. This was hung up over a stove or lamp, and its spiral form caused it to rotate. An Ipiutak spiral, if hung above a blubber lamp, would have rotated in the same way.

Eating and drinking represented the utmost felicity for which the Eskimo could hope. Lyons, a British explorer in Arctic Canada, the artist and companion of Sir William Edward Parry (1796-1855), describes their hearty appetite:

Kuillitleuk had already eaten until he was half-seas over. He was dropping asleep, with a red and burning face and

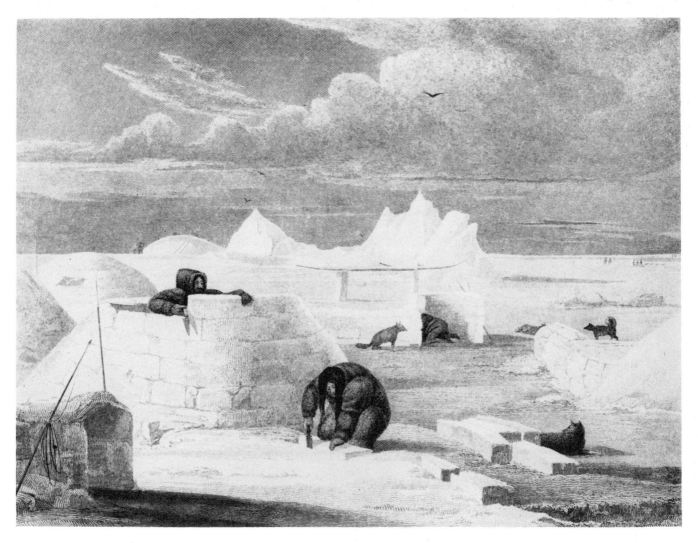

16 Eskimos building a snow house at Igloolik, Canada. The builders unerringly cut snow blocks which fitted exactly into the wall of the house. Sketch by Lyon, 1822

open mouth. His wife was cramming him, stuffing bits of half-boiled meat down his throat with the help of her first finger, steering clear of his lips. She carefully watched the process of deglutition, and immediately filled up any void that might appear in the orifice with a stopper of raw fat. The happy man did not stir; he moved nothing but his molars, chewing slowly, and not even opening his eyes. From time to time a stifled sound escaped him, a grunt of satisfaction.

The flesh diet on which Eskimos lived almost entirely contributed to the high metabolism which enabled them to withstand the cold. It also gave them the energy required to carry out very arduous kinds of sculpture, such as ivory carving, which is hard work, even when carried out with modern tools in ideal conditions.

The large quantities of water which they drank continually produced large supplies of urine, which was used for softening ivory and bone, and for many other purposes.

Most of the raw materials for Eskimo art, with a few trifling exceptions, such as wood, amber, and soapstone, were by-products of the chase which they had to carry on continually to obtain the vast quantities of food they required. Many of these raw materials had been adapted to art production with the utmost ingenuity. Thus blood was used to cement soapstone vessels when they had been broken.

The material principally used for vessels for boiling food (the only form of cooking which was carried out except in Alaska, where stone frying pans were used) was soapstone. The Eskimo first mastered this substance so as to use it to make cooking gear — only much later did they think of adapting it for sculpture. Nowadays of course it is the most important sculptural material, while the polish used to finish it is blubber, an essential element of Eskimo diet.

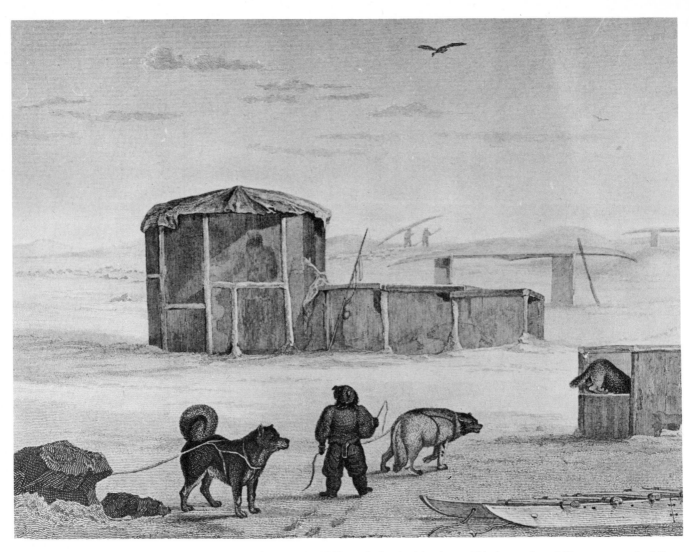

17 A temporary snow house, built in Igloolik, Canada, in 1822, and sketched by Lyon. This house is quickly constructed of flat slabs of ice, laid on end and cemented with snow. Skins cover the roof. Note the dog breaking into the cache on the right and the sledge in the foreground

The daily bread of the Eskimo was seal meat, eaten in a variety of ways, raw, frozen, dried, or half-rotten, but usually boiled. The meat was cooked in a soapstone pot over a blubber lamp (also made of soapstone) over which the pot was hung. Pieces of the meat were then cut off with a knife, each being so cut that a piece of blubber was left attached to it, which served instead of vegetables or gravy. The meat was then skewered with ivory or bone forks, shaped like miniature harpoons. The soup left after the meat had boiled was looked on as a special delicacy,

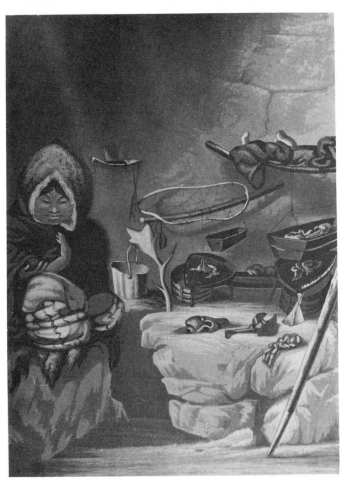

18 Interior of a snow house on Winter Island, Canada, 1822. On the stove made from blocks of snow, blubber lamps with a line of tiny flames along the edge, stand over dripping pans, with cooking pots made of soapstone above them

and much drunk by women, somewhat like afternoon tea among Westerners. Eskimo women who were not invited round for soup drinking by their friends would take umbrage and might even challenge them to a drum fight — a sort of formal slanging match accompanied by satirical songs.

Whale, caribou, walrus, bear, ptarmigan, eider duck, guillemot, puffin, and many other animals and birds were eaten. Many fish entered the diet, shark, salmon, caplins, Arctic char, herring, trout, and sea urchins being only a few of them.

Vegetables played a comparatively small part in the Eskimo diet. Crowberries, bilberries, seaweed, and other plants were gathered and eaten. The half-digested vegetable contents of animals' stomachs were also an eagerly sought-for delicacy.

As opposed to the strictly non-artistic treatment of houses, Eskimo eating implements show a marked artistry. Bowls, mugs, spoons, even the water buckets in which snow was left to melt, were all carved and ornamented with the utmost finesse.

Boxes and bowls cover an enormous range of forms in Eskimo art, some being extremely elaborate and ornamental. A wooden box from Alaska, for instance, was ornamented by darkened chisel work and set with scrimshawed heads of animals, with scrimshawed side staves and handle. Equally laborious, because they had to be chipped from a solid block, were boxes cut from wood. They were ornamented with paint, wood carving, ivory cut-outs, and even with precious stones such as turquoises. Some boxes had toggle-locks. Small and beautifully ornamented boxes were made to contain trinkets, and later on snuff, when it became available. The simplest, however, was fish skin, tanned and equipped with draw strings, in which a craftsman kept his set of tools.

Pottery lamps and vessels, the lamps decorated with incising, the vessels by stamps, have been found in the Central Bering Sea coast, and pottery has also been found in many of the sites associated with the oldest Eskimo cultures. Some Alaskan pots are covered with line and dot patterns. Prehistoric people, such as the Old Whalers, used stamps to decorate pottery. Although some of the patterns used are not without their charm, little enough of any kind of pottery has survived that has a marked aesthetic appeal.

Stone, particularly soapstone, was the material which above all others, was used for cooking pots, and the lamps which hung underneath them. Before soapstone was in use food was cooked by simply immersing hot stones in birch bark containers. Soapstone lamps and pots seem to have been always undecorated, though there are some ornamented stone lamps from prehistoric sites, such as a really fine stone blubber lamp of the Kachemak culture in Alaska, decorated with a crouching sphinx-like figure. Though plain and unornamented, the lamps and pots are often of good design. They were very laborious to make, although soapstone is very soft. Frank Wilbert Stokes, an American artist, drew a picture of an Inglefield Eskimo making a soapstone lamp in 1893. His tools consisted of an adze and a crescent shaped knife. Soapstone is an ideal material for any vessels which have to come near the fire, because it withstands heat very well, and once really hot, bakes to a glassy, ceramic-like hardness. The Eskimos showed great skill in working soapstone and carried out the well nigh impossible task of mending it with a cement compounded of blood, clay, and dog-hair.

A very large variety of eating utensils were used by the

Eskimos. They excited the admiration of Cook, who wrote: 'Their household furniture consists of bowls, spoons, buckets, piggins or cans, matted baskets, and perhaps a Russian kettle or pot. All these utensils are very neatly made and well formed, and yet we saw no other tools among them but the knife and the hatchet.' Although the bowls and spoons that Cook had been inspecting were made in the Aleutians, he would have found just as much to admire in similar articles made in Greenland. Oil spoons, drinking cups, dippers of bone and wood, all are masterly pieces of design. Even utilitarian objects such as water tubs and drinking cups were carved from substantial wooden sections and ornamented profusely with ivory cut-outs, and given sinew handles on which were threaded ivory and bone beads.

When not cut out from the solid, dishes and bowls were made very cleverly by bending thin pieces of wood into a circle, stitching the ends together, and then fitting a base. The Eskimo displayed an ingenuity in dealing with apparently intractible materials, which the modern sculptor can only envy. When an Aleut needed glue, he struck himself a blow on the nose, and used some of the blood. When a sculptor began to work that hard and unrelenting material, walrus ivory, he softened it beforehand, and as he proceeded, by steeping it in urine.

Although granite pillars were used in Canada to build caches, most stone work was on a much smaller scale. Stone was split by wedges hammered into cracks, and shaped by hammering with a stone maul or a sandstone saw. The Eskimo had discovered, empirically, that sandstone could cut any other kind of stone because the grains of which it is composed are pure silica, which is harder than the hardest stone which Eskimos shaped, which was jade. Stones which had to be hollowed, such as those being made into lamps, were pecked out with a hammer stone and smoothed and polished with a stone rubber. Flint points and blades were roughly hammered into shape and then re-touched with a bone shaper. There was an Aleut proverb to the effect that no young man should marry until he had worn down to the stump the penis bone of the sea otter which was used as a re-touching tool. A hand guard of sea-lion skin protected the workman

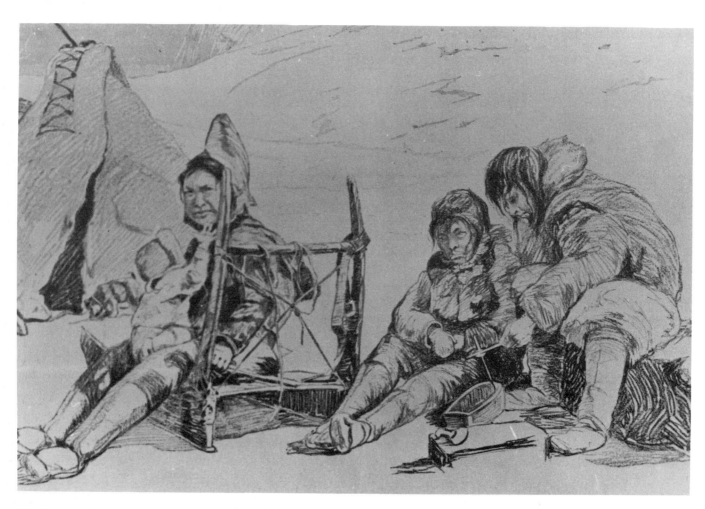

19 The first picture of Eskimos carving soapstone, drawn by Frank Wilbert Stokes in Arctic Canada in 1893

while the re-touching process was being carried out. Slate, which, like flint, was used for weapon points, was roughly broken into shape and finished with a rubbing stone and bow drill.

Soapstone was the most easily worked of all stones, and it was used for lamps and cooking pots when available. It was carved with an adze and a crescent-shaped knife. When broken, pieces of a soapstone pot would be cemented together with a blood and dog-hair cement. This was heated over a blubber lamp till it had set hard. It is worth mentioning, as a fact that has escaped previous commentators on Eskimo soapstone work, that pieces of soapstone will actually vitrify and fuse together if exposed to sufficient heat. So a mended pot might be further welded by the heat of the cooking flame.

By means of simple tools such as hammerstones, V-shaped sandstone saws, polishing stones, and bow drills tipped with flint points, Eskimos could successfully hole soft stones like turquoise, jet, and amber. No one has commented on how the jet and ivory artificial eyes, noses and teeth made to fit out skulls by the Ipiutak people were carved. Probably the jet was worked with flint blades and then rubbed on the hairy side of a pelt. The lanolin in the fur would polish the jet, which can easily be burnished up into a fine finish with any kind of grease or oil.

The only sources of ivory available to Eskimos were whale's teeth, fossil mammoth ivory, and walrus ivory. There was no great problem about working the first two ivories. They were softened up by being steeped in urine, and carved by having hollows cut in them made by two V-shaped cuts which approached one another. Ivory would be cut into sections by being sawn or notched and broken off. Wedges of ivory or bone would be driven into a block of ivory to split it. All these were very wasteful methods. Stone adzes could cut through the toughest ivory, but only at a woeful expenditure of chips. Finishing and polishing were done with flint scrapers, polishing blocks of andesitic lava, andesitic tufa, and with horse-tail. Although ivory could be engraved very skilfully by the Eskimo, using their primitive tools such as flint burins set in wooden handles, or beaver's teeth, (these have an enamel exterior much harder than ivory) the ivory carvers were very quick to relinquish their Stone Age tools in favour of European files, saws, and scribers, as soon as they could obtain them.

Scrimshaw, so characteristic of Eskimo art, may have originated as a procedure to stop the warping of ivory. A slab of walrus ivory would not warp, provided it were carved out of either the homogeneous exterior, or the spongy and more open interior. If a carving included both interior and exterior tusk, however, it would warp, the layer of lesser density contracting, and drawing the rest of the ivory to it. All ivory is likely to warp, especially if exposed to changes of temperature. To avoid this the Aleuts and other Eskimos cut deep grooves on the surfaces of their carvings. So the custom may have arisen of giving an incised decoration to all plain ivory surfaces. The

parallel lines, zigzags, dots, and circles, which usually occur on just one side of a flat carving, may have been made to avoid warping. The deep incisions found on some animal carvings, which are described as 'skeletonised' motifs, may have had the same end in view.

20 Snowy owl, carved from a walrus tooth, Igloolik, Canada

Like ivory, bone was shaped by stone saws, or with crooked knives, curved knives which were made up of several pieces of flint set in a bone or wooden handle. Bone was chipped into the right size by cutting a V-shaped groove round it with an adze, the pieces on either side of the groove then being snapped apart. The bone could be reduced further in size by wedging or drilling. Bone carvings would be smoothed down with a rubbing stone and carved with chisels, burins, slate knives and the bow drill.

Wood was chipped into shape with an adze. There were no proper wood saws, so planks had to be wedged or adzed into shape. Wood carvings were made with a crooked knife. Holes were made by means of a drill twisted round with a thong, which required two men to work it. A smaller bow drill could be used by an individual working by himself. He held one end of the drill shaft in his mouth, holding the work to be drilled with one hand and working the bow with the other. Small details were cut in with a beaver tooth chisel, the butt end of which was occasionally shaped to be used as a smoother and polisher.

Skins were scraped with a woman's knife, while being held down on a stool, then rubbed over with an abrasive block made from bear's bone, pumice stone, or sandstone, or a special scraping board. When cleaned, the skin was then pegged out to dry. Next it was soaked in urine, washed in sea water, and rendered pliable by handling, before being pegged out on a frame once more. Skins which had to have the hair removed, such as those for *kayak* covers, would be given a longer time in the urine dip. The time spent in it determined whether they were going to be black or white skins. Next they had to have the hair stripped off by chewing the skins, or by working them with a knife. Those skins which were destined to cover a *kayak* or an *umiak* were rendered watertight with a solution of boiled oxidised whale's blubber. Hides had to be given extra pliability because they were intended for close-fitting garments or for boots, and these too were

chewed by the women. The skins were then stitched with ivory needles, using thread made from narwhal or bear sinews, twisted or plated into longer skeins. Special sinew plaiters were used to do this. Thongs were also straightened and shaped by pulling them through perforated ivory tools like wire drawers.

21 Polar bear swimming, from Igloolik in Canada. Dorset culture. *c.* 700 B.C.–A.D. 1300. Note 'skeletonised' decoration

The Eskimo were passionately fond of games, indeed they still are. During the brief period during which they were on friendly terms with the English explorer Martin Frobisher, his sailors taught them how to play football, and the first international match between England and Canada was played on the ice in Hudson's Bay. Whenever it was possible to play outside, Eskimos preferred outdoor sports, such as jumping on a tightly stretched blanket, which acted as a sort of trampoline, or playing ball. Balls of sealskin, ornamented with fringes and stuffed with moss, were tossed from player to player without being allowed to touch the ground. Other Eskimo ball games included a rough kind of shinty, played with a heavy ball and massive, spoon-shaped bone clubs. But for a large part of the year only indoor games were possible. Many of these were Eskimo inventions, and extremely ingenious. They included a game in which a polar bear carved in ivory, and perforated with many holes, was thrown up and caught on a miniature spear. The bear was attached to the spear by means of a thong. A carved fox head was also used, and the point of the game lay in catching the carved animal on a series of preselected spots in succession.

28

In another similar game, an ivory weight was hung from the roof, with a lozenge-shaped piece of ivory attached above it. There was a hole in the lozenge, which was spun round and then suddenly stopped. The players standing round tried to pierce the hole with a stick, and the winner was the one who succeeded.

A game rather like knucklebones was played with beautifully carved figures of birds, men, and animals. It was called by a name that meant 'Images of Birds'. Fifteen ivory gaming pieces were thrown up over a hide. Those which fell so that they stood upright, and which remained facing a player, would be taken by him. The player who got the largest number of pieces won.

Alaskan ivory guessing-game pieces, resembling dice, have been preserved, consisting of barrel-shaped pieces which might be plain, marked by circles and spots, or with transverse lines. A player would put his hands behind his back and then suddenly bring them out, one hand clutching a piece. The other players had to guess which it was in.

A game of cat's cradle was played with a loop of string stretched over extended fingers. Figures would be formed out of the string and onlookers would be invited to guess what they represented. Closely allied to the cat's cradle figures were puzzles made from a bone frame, on which

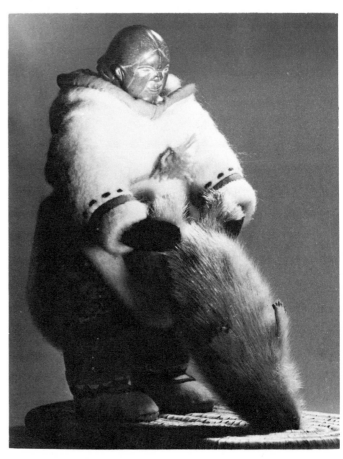

22 Modern Canadian sculpture from Port Harisson. Artist unknown (Canadian Arctic Producers Ltd)

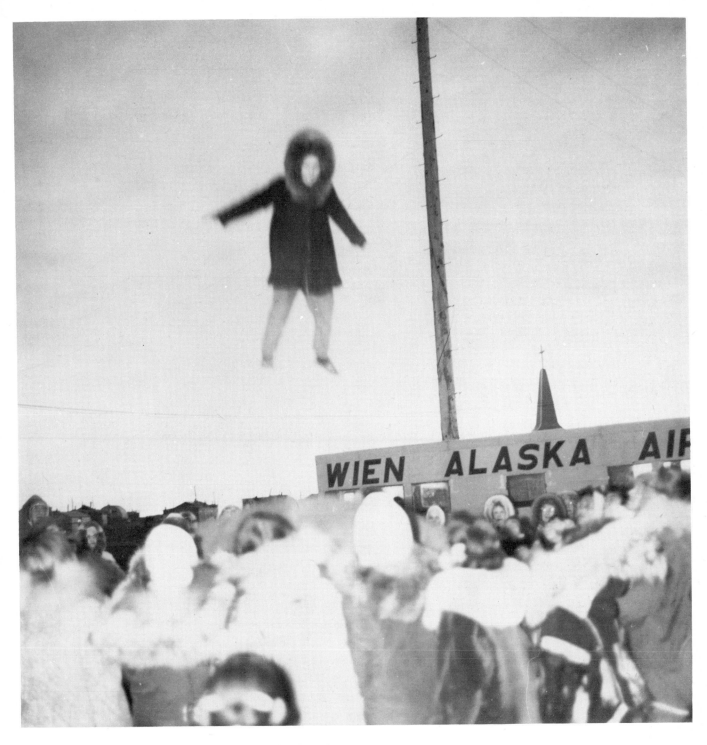

23 Alaskan Eskimos blanket tossing (Photo Bernadine Bailey)

was a string threaded with moveable beads. All the beads had to be collected on to one spot on the string.

During their short childhood, Eskimo boys and girls played with dolls which had wooden bodies, and real fur clothes, or with model *kayaks,* sledges, *umiaks* and bows and arrows. Many of these art forms have now received a new lease of life, as they are the sort of souvenirs that tourists in Greenland and other parts of Eskimoland will buy. Many of the toys made for children were wooden or ivory animals. Some were carved realistically, others abstractly. Some had special features, such as artificial bones inserted in the limbs.

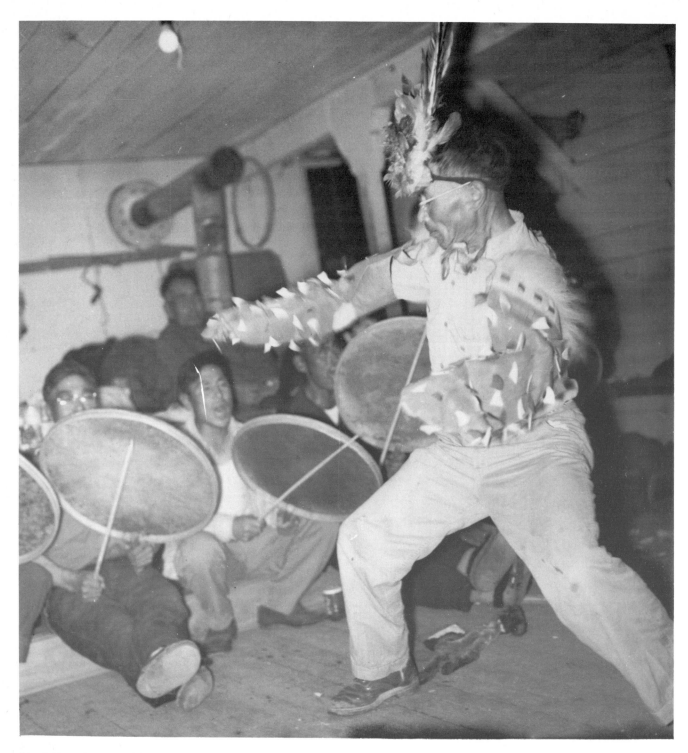

24 Eskimo dancer and drummers at home, Alaska

The doll's house often takes in what the temple has thrown out. Some at least of the many wooden and ivory images which have been accepted as being toys were really shaman's dolls which had fallen into secular hands. Harpooned seals, with the harpoon lines attached to ivory floats, are often too highly decorative to have been toys. Other ivory images, pierced for suspension, may have been magical images which trimmed the *parka* of the *angekok*, or which he suspended in his hut and smeared with blood to ensure good success in hunting.

Objects which were certainly intended for toys include the 'pecking birds'. Two ivory birds were positioned on one wooden rod, with their feet attached to another rod, fitted into the first. When the rods were moved the birds began to peck.

Other toys included wooden tops, spun by twisting the

stick between the fingers, and musical toys such as whizzers. These were propellor-shaped wooden toys attached to strings. When they were pulled through the air they made a buzzing noise. Bull roarers were wooden slats, shaped like leaves, which whirled through the air at the end of an attached thong like a whiplash, making a fearsome roar.

Other noise-making toys included rattles made from bear's teeth, perforated and attached to a handle, and spindle whizzers. This toy consisted of a wooden axle, inserted into a block of bone or soapstone. The axle passed through a small bone handle. A rawhide thong was attached at one end to the axle, at the other to a short bone handle, like the handle for a pull-starter of an outboard motor. The thong was wound round the axle, then pull-started, after which it would make a buzzing, grinding noise for half a minute as it spun round in the bone block.

Seal's knucklebones were used to represent sledges, dog teams and houses for dolls. They were also built up into diagrams which represented animals, human beings, boats and other subjects, then thrown up, and dropped, so that they occupied different positions. These positions determined which player should take them. The bones also seem to have had a secondary use, for divination, like tarot cards.

Five of these seal's knucklebones were found in a child's wooden toy box, along with twelve teeth, two toggles for dog traces, three buttons, a nozzle for inflating seal's intestines for floats, two pieces of mounting, which may have been thong straighteners, three miniature buttons and a miniature soapstone pot.

Obviously Eskimo children, like those of any other society, found it just as amusing to play with objects not intended as toys, but which were really valuable pieces of adult equipment; the fact that this particular child was able to commandeer so much shows how indulgent Eskimos are to their children.

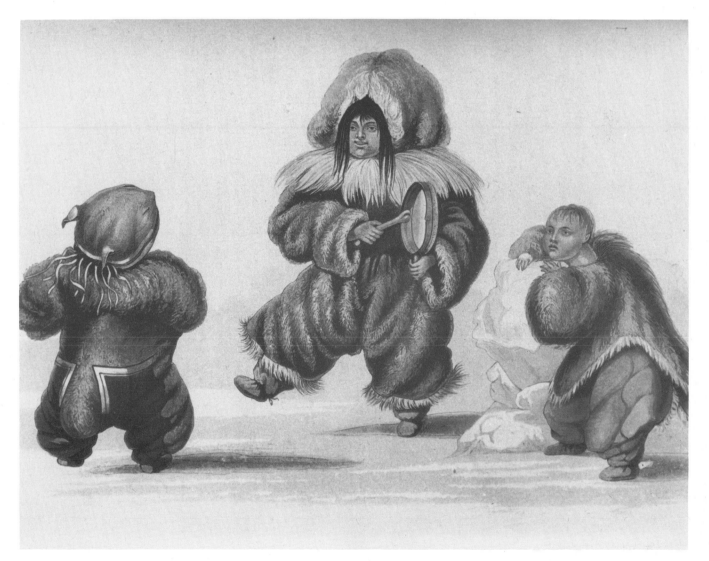

25 Eskimo children at Igloolik, Canada, dancing to the sound of a drum. The drum is a miniature version of the shaman's drum and the child is striking it with a bone drumstick on the wood, not on the tympanum, so as not to damage it. Sketch by Lyon, 1823

The world of spirits: religious objects and ceremonies

Men believed that every stone, mountain, glacier, lake, and promontory had a spirit of its own, called an *inua*. Animals had spirits too, though for some reason dogs were excepted from this rule, in Alaska at least. Men possessed several souls, or spirits, one of which was closely connected with the owner's name. Another soul was called *tarnik* in Greenland, a word closely related to the word for 'shadow'. The name of a person, or an object, was connected to his soul. It was dangerous to speak aloud the name of a glacier over which one was travelling or mention the name of a headland as you passed it, as their *inua* might become offended. It was even more important never to tell your name to anyone, lest he prove to be a wizard, and obtain power over you.

The soul could leave the body, become lost, or receive damage. In the latter case it had to be repaired by that skilful carpenter of souls, a shaman or *angekok*. An ill-disposed *angekok* could send his familiar spirit, or *tornarssuk,* to eat the soul of an enemy. These beings were always red with the blood of the souls which they had eaten.

After death the soul continued a half-life in the grave, whence it could return and harm the living, and where it could be visited on the feast of commemoration of ancestors. It need not stay in the grave but could pass to some other abode. Wherever they were, the dead were chancy folk. Fear of death dominated the living, making them wind up a dying person in his grave clothes before life had departed from him, or even forcing them to wall him up in a snow house. The same dread compelled them to throw away or destroy the dead man's possessions, bury them with him, or leave them on the shore if his body had been cast into the sea.

Two abodes lay open to the dead. The more fortunate among them went to a land below the earth, a country where there was always beautiful sunshine and seals and other game in abundance. The other dead, who as always in this kind of division make up the majority, went to a starry limbo above the earth. Even there all was not woe, for the children at least. When winter came, and the Northern Lights shone, folk below told one another that the spirits of the children were playing ball, with a ball made from the skull of a celestial walrus. In Greenland at least, only women who died in childbirth, men drowned at sea, and whalefishers, went to the Good Land under the earth — all others went above.

The categories into which the Blessed were divided bear a strong resemblance to those which divided the dead who were carried off by the Choosers of the Slain to Valhalla, the home of the dead in Norse mythology. Many other Eskimo beliefs, in Greenland at least, seem to echo Viking lore and suggest that they were inspired by the lore taught to the Eskimo by the Viking Greenlanders. They certainly include the Viking custom of displaying the body or head of a dog at a funeral, the idea that the way out of this world lay across an extremely narrow bridge, and through horrendous swamps, the belief that evil spirits can be set as assassins to kill enemies, and that giants, trolls and outlaws lurk in the mountains.

However, there is one difficulty in believing that these religious ideas are of Norse origin: they are almost all held by the Western Eskimo. The Alaskans too, believe that the *arcissat,* or blessed, are recruited from heroic whalers, good sailors drowned in tempests, men of courage who have committed suicide rather than live as a burden on their families, and 'well-tattooed women' who have died in childbirth. Either these ideas moved eastward from Greenland after the Vikings settled there, right around the world in fact, which seems impossible in view of the fact that cultural development moved from Canada into Greenland after the twelfth century, or else the Norsemen must have derived them from the Eskimo. No suggestion could be less welcome to any Scandinavian. I can still remember the look of hatred on the face of an Icelandic guide as he told his little flock of tourists that there had never been any Eskimos in Iceland. Both Iceland and Greenland however, are the nearest points of European contact with the Eskimo during the Middle Ages, are likely spots for such beliefs to have filtered through from one set of people to the other.

As everything and everyone owned a spirit, there were as many gods as there were objects and beings in the

universe. Even the spirits of Europeans — *kablunas* who dwelt far to the south — might be conjured by a skilful *angekok*. Sacrifices might be made to a very wide variety of spirits — such as those of headlands and glaciers for example — but in practice there were only a few gods who were worth propitiating. They included the more powerful spirits, called *tornat,* who could be harnessed by the *angekok* to act as kindly helpers in sickness or misfortune, or avenging ghosts which could destroy a victim body and soul. Superior spirits, called *tornarssuk,* presided over the lesser ones. It was on them that the *angekok* concentrated when he proceeded to invoke spiritual helpers.

The animals of the sea were ruled by 'the old woman', whose name was *Arnarkuagssak.* She was the patronness of hunters, for marine animals were generated in the melted blubbers of the dripping dish below her lamp. If she was in good humour she would allow them to pass into the terrestial seas, where hunters could kill them. If, on the other hand, she was bad tempered because the lice in her hair were troubling her, she would sulk and refuse to send any game. It was therefore, one of the major tasks of the *angekok* to comb her hair. This was an impressive performance, in which several shamans cooperated. They were able to convince their audience that the lice had passed to the fearsome abode of Sedna, combed her hair, and thus ensured good hunting.

All sorts of being, other than man, and the spirits of the dead, peopled the world of the Eskimo. They included sea-spirits, *ignerssuak,* who were visible as flames, troglodytes who dwelled inside the hollow hills, giants called *tornit,* who could be seen stalking over the sea, and many others. Everyone tried to control the beings of the other world in so far as he could, practising his own individual magic, copied from the professional practices of the shamans. Men and women carried amulets, uttered the charms or songs which activated them, performed sacrifices, or carried out magical rites. Just to give one example, at the New Year men and women in Alaska danced together naked in the moonlight, wearing eyeless masks, kept in their places by a strap buckled behind the head and a bit held between the teeth. While the mask was on, the wearer was under the influence of the spirit which it represented, hence it would have been death to see anyone else's mask.

Full control of the spirit world was reserved for the *angekok,* a semi-benign shaman, and the *ilisitsok,* a wholly malevolent warlock.

Angekok looked after all the spiritual needs of the community and most of their bodily ones as well. They were called in to cure illnesses, they presided over the formal orgies, as opposed to the casual promiscuity of the village, created good weather and good luck for the villagers and took the presiding role in the formal ceremonies which entered in the religious year, such as the Feast of Sedna. Like the mediaeval priest, who was occasionally a black magician as well, the *angekok* could

just as easily harm as well as heal. Hence it was essential that he should be paid well for his ministrations. Only he could protect the villagers from the spells of the *ilisitsok,* evil magicians whose identity was unknown to the community, but who were constantly practising harmful magic against individuals. Much of their mischief centred round the creation of *tupilaks,* spiritual robots programmed to home on an enemy and kill him, often by drowning him. These beings took the form of images constructed by putting together weird and horrible pieces of dead human beings, animals or birds. They were infused with malevolent force by the *ilisitsok* 'begetting' them between his legs, and uttering a charm over them. Only the *angekok* could intercept and kill these fearful beings.

Although the *angekok* led an enviable existence, fed and clothed at the expense of the community as a whole, it was not everyone who could become one. A future shaman had to have a calling, often announced in a dream, and spend a long apprenticeship of ten years or more in solitary retirement in the wilderness. Terrible experiences accompanied the path to illumination, or so the *angekok* told his flock when he returned to them. In the Aleutians, the neophyte would set sail for some uninhabited island, where, in a secret cavern, the mummified remains of some famous shaman had been concealed. The ancient shaman sat, stiff and cold, his face masked, his body robed with furs ringed with ivory marmosets, big and little bells, tiny chains and rings, eagles' claws, serpents' teeth, fish scales, pieces of hard leather, and other small objects which rattled as the wind swept through the cavern. By means of the properties he wore the shaman could be put in touch with the spirits governing the animals and the elements. Beneath the knees of the old prophet was placed a drum, upon which was painted the circle of the universe, the cross of the four winds, and magic figures of men and animals. The interior of the drum contained tiny images representing spirits, each of which would respond to a blow struck in a particular way.

Greatly daring, the neophyte took the drum, struck it, and summoned the seer to leave his sleep of death. At the noise the corpse started, the feathers of the screech owl's wings which crowned his cap fluttered, and the mask shook. Encouraged by these signs the neophyte removed the dead shaman's mask, uncovering a black, grimacing, mummified face. The two hollow eyesockets in the black, grimacing, skull-like face contemplated him, casting on him rays of darkness.

The living saluted the dead by rubbing his nose against the exposed nasal bone of the corpse, and then passed his hand across his stomach as though to say 'How delightful!' With the politeness of a guest towards his host he smeared his palms with saliva and rubbed the blackened countenance of the illustrious dead. Then he made an offering of tobacco, and the liver of a bear, which is poisonous to the living and therefore a great delicacy for the dead. At the sight of these delicacies the parchment

lips smiled feebly, and the little sticks fixed in the top of the skull shook from side to side, tokens that the neophyte was well received. By the light of a shell filled with oil, in which a wick of moss burned, master and disciple conversed the night long. The disciple interrogated, the master replied by phosphorescent writings in the brain. The spirit of the old dead shaman passed into the new living one, the transference being symbolised by a tooth which the neophyte tore out of the mummy's jaw, and henceforth kept concealed in his own mouth.

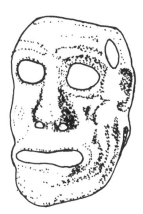

26 Reconstructed ivory head from Point Hope, Alaska. Ipiutak culture, c. A.D. 300–1000

In Greenland, the apprenticeship of an *angekok* was even more thorough going. First he must die, and then come to life again. He must be seized and dragged to the seashore by a bear, then gored through the genitals by a walrus, which would then carry him off to the horizon and eat him up. Now his bones would set off homewards, and on their way, meet the shreds of his flesh, and knit together with them.

A fully-fledged *angekok* laid claims to the widest powers. He could change his sex at will, become pregnant, pluck out one of his eyes and swallow it, and stab himself without doing any harm. He could summon a bear, a walrus, or a whale to convey himself across the seas. This is another Eskimo belief which the Norsemen were to acquire: the most famous of all mediaeval Icelandic scholars left his studies in Rome and hastened home to claim a benefice riding on the back of a seal.

Angekok established an enviable dominance over the whole of the village. Their authority was greater than that of the chief hunters, though of course if the community had an appalling run of bad luck it was possible that the *angekok* might experience a fatal eclipse of popularity. The shamans were clever enough to dominate their fellows just by force of personality. The Christian missionaries in Iceland soon found out that they could not out-argue the *angekok,* so they used a cudgel to them instead. All sorts of tricks were used by the shamans to impress their credulous flock. They practised

ventriloquism, escaped secretly from apparently unbreakable bonds, and emitted phosphorescent flashes of light, which perhaps they manufactured from rotting fish.

What effect did religion have on Eskimo art? It undoubtedly supplied the incentive to create a large variety of art objects, masks, ivory shaman's dolls, and so forth, which will be discussed in their place. It also provided a large part of the subject matter of the arts. Many of the symbolic ivory cut-outs represent spirits; much of the subject matter of what is often considered secular art may originally have been inspired by religious ideas which are now completely forgotten. Thus masks intended as amusing toys were still copies of similar masks made by shamans for religious ceremonies.

27 Model in wood of a *tupilak* from nineteenth century Greenland

Many apparently secular objects may have been made originally for religious purposes, or at least have been modelled on the lines of religious art. Thus *tupilak,* which were really intended to be spirit dolls made from pieces of human beings or animals, were often copied in wood and are among the most forceful pieces of sculpture. On the other hand, many pieces of secular work acquired religious significance. This was particularly the case with amulets which could be made from discarded pieces of old hunting gear, such as spear-throwers, or *kayaks.* Specially shaped amulets took various forms. In Greenland they were small male and female dolls carried in pouches of a special harness worn across the shoulders. Carved masks superimposed on one another in six-sided blocks called *innerturin* ('the fire people') were also carried. The origin of these carvings can be traced back to the middle ages in Greenland. Wooden carvings of *tornarssuks* were also carried.

Idols had been carried by the Greenlanders when they met the first missionaries in the eighteenth century. One of the ivory masks which served as harpoon-line runners was collected from Canada by Sir Hans Sloane during the eighteenth century. Various wooden figures from

Greenland, which have been classed as dolls, probably represent spirits or monsters.

Masks were worn at various ceremonies, and diminutive finger masks were also in use. Greenlanders had originally used masks in the *angekok* ceremonies. When Christianity made its appearance these masks were only used to play games and to frighten children (compare their use for the same purpose in Old Japan). In Alaska, masks played a more important role. They were used to cover the faces of

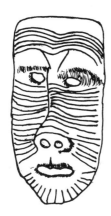

28 Secular wooden mask, from nineteenth century Greenland

the dead, worn in social dances, and used to caricature individuals or to represent spirits who might help the hunters. Sometimes spirit masks were extremely complicated, incorporating hinged outer masks which could be pulled apart by a string, or movable limbs and other parts.

Drums, which, like masks, were used in ceremonies, were basically religious. A drum consisted of a wooden or whalebone hoop with a long handle, covered with a drumhead of polar bear intestine, which was lashed round the drum with twisted sinew. It was beaten by striking the wooden frame with a beating stick. This might be carved from ivory or wood, or be otherwise ornamented. The drum was an essential part of the shaman's apparatus for raising spirits.

Tupilaks were spirit dolls made from organic materials, vitalised by a ceremony in which an evil magician 'gave birth' to them, given life by the reciting of spells, and then sent out across the sea, or ice, to kill an enemy. These *tupilaks* are always known from models. An example is a wooden doll, lashed all round with raw hide, with open mouth in which were inserted two children's teeth, and deep set eye-sockets, which in the original *tupilak* had contained two children's eyeballs.

Tombs were of only occasional occurrence. Many of the dead were thrown into the sea, or hastily interred under rough stone cairns. Parry, an English explorer in Canada, was shocked by the way Eskimos allowed their dogs to

36

disinter and eat recently buried corpses. The interment of the living but elderly or moribund in their snow houses also horrified other observers.

In Alaska, however, more attention was shown to the dead. At the village of Kaltkhagamute there was a graveyard containing:

> a remarkable collection of grotesquely carved monuments and memorial posts, indicating very clearly the predominance of old pagan traditions over such faint ideas of Christianity as may have been introduced to these people. Among monuments in this place the most remarkable is that of a female figure, the general cast of features resembling closely a Hindoo goddess, even to its almond eyes. Natural hair is attached to its head, falling over the shoulders. The legs of this figure are crossed in true oriental style. The whole is protected by a small roof set upon posts. Other burial posts are scarcely less remarkable. Nearly all these figures are human effigies, though grotesque and misshapen and drawn out of proportion. No images of animals or birds, which would have indicated the existence of totems and clans in the tribe, were to be seen, but here and there, over apparently neglected graves, a stick, surmounted by a very rude carving of a fish, a deer, or a beluga, indicative of the calling of the deceased hunter, could be discovered. (*An Arctic Province,* Henry W. Elliott, London, 1896, p.410.)

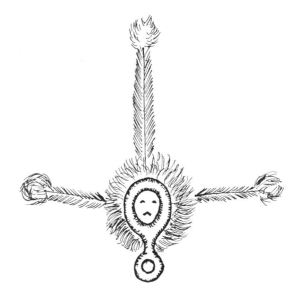

29 Finger mask from Alaska

Alone among the Eskimo peoples, the Alaskans and Aleuts practised mummification. The house-like tombs of a modern Alaskan cemetery are derived from the wooden boxes with slanting roofs in which mummies had been packed before being hung up in caves. Mummies of important Aleuts, such as hunters or chiefs, were dressed in armour and masked.

30 *Tupilak* from Greenland, probably carved at Kulusuk. The artist has shown great versatility in carving a figure out of a whale's tooth, which has a large hollow in the middle (Photo Stella Mayes Reid)

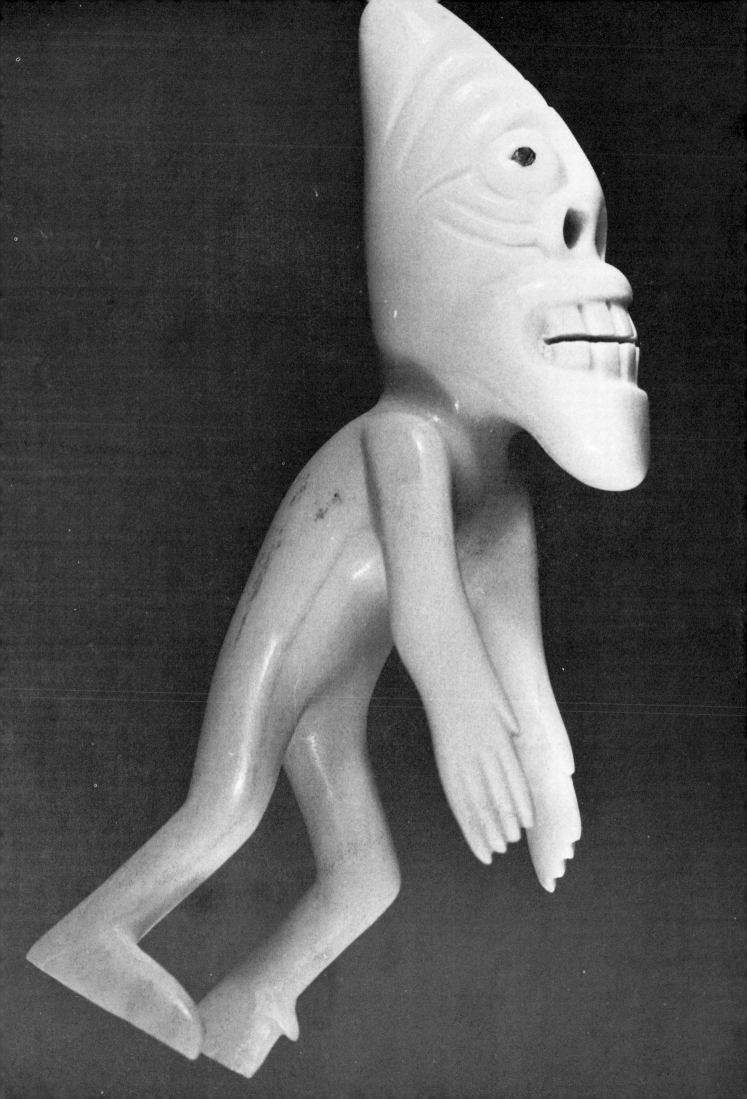

Mummification was carried out by slitting the stomach with a flint knife, removing the intestines, and cleaning them. Repacked with sweet smelling dried herbs, the corpse was then dressed in fine clothes, over which a *kamleika* or raincoat made from the intestines of whales or walrus was drawn.

The dead man was arranged in the squatting position adopted by Aleuts when resting, wrapped in grass mats and sealion skins taken from the cover of the dead man's boat, and tied into a compact bundle with rawhide, thongs or seaweed ropes, with an outer covering of a net of sealion sinews. Finally the mummy was deposited in a cave which was regarded as the dead man's eternal home. Caves served as temporary homes for Aleuts who were camping out while hunting.

An impressive round of feasts and festivals broke up for the Eskimo what would otherwise have been the unbearable monotony of the hunting year. Though the calendar differed somewhat in different parts of Eskimoland, people as far apart as the Aleuts and the Greenlanders would celebrate identical feasts at approximately the same time — no small testimony to the homogeneity of Eskimo culture.

In summer, feasts and other ceremonies would be held in the open. In winter, they would be held in one of the communal rooms or houses of an Eskimo village. In Canada, these feasts were held in a specially constructed 'Singing House'. This consisted of a snow dome fifteen feet high and twenty feet wide, with a pedestal in the middle to hold the lamps which illuminated the feast. The villagers, dressed in their best, ranged themselves in places which depended on their age, sex, and marital status. An entertainer, stripped to the waist, and carrying a drum, sang and danced to the assembled company, amusing them with songs which poked fun at the different members of the audience. As in so many aspects of Eskimo culture, it is difficult to draw the line between religious and lay activity. Thus the singing house was sacred to a *tornak*, and accordingly anything which took part in it could be considered a religious ceremony. In Greenland, traditional songs were sung before the audience by men or women singers. Their tones imitated the sound of a running stream, which, the Eskimos felt, echoed the chant of the dead.

Many more informal feasts occurred when one party of friends called on another. Often the host would be eaten out of house and home, but he, as well as everyone else, would regard this as just part of the fun.

Drum fights were a way of settling quarrels which might otherwise become serious and end in murder and revenge killings. If a man felt that he had been wronged by another, he could issue a challenge to a drum fight. In fact it was most often the women who felt they had been slighted — one woman, for example, challenged her friend and neighbour because the latter had not asked her round for an afternoon cup of seal soup. Each party in a drum fight would take the floor by turn, and sing satirical songs about his opponent, blow in his face, buffet him and otherwise insult him. He would take care to bring up all his opponent's faults — and to invent a few more, such as to charge him with being a cannibal. The defeated contestant in a drum fight might well become the laughing stock of the whole community, and in Alaska, contestants who feared defeat would send an ambassador to their opponent. The ambassador, dressed in new red flannel, and carrying a stick decorated with feathers, would offer presents as a help to negotiating a settlement between the two parties. If the other contestant showed signs of wavering, he would offer double what the other demanded, so as to reconcile their differences.

Every autumn, Sedna feasts were held. Sedna was the goddess of the underworld, and it was important for the village to neutralise the evil influences that she would try to exert on them during the winter, the time of her greatest strength.

After impressive displays of conjuring by the *angekok*, who would call up Sedna to a breathing hole and then harpoon her, dance processions would proceed through the village, and there would be a ceremonial tug of war. Then, to the terror and astonishment of the assembled crowd, two mysterious masked figures would stalk into their midst. They looked gigantic, because each wore several layers of clothing, multiple pairs of trousers, a woman's overjacket, and heavy boots. Masks of sealskin concealed their faces. Each visitor carried an inflated sealskin float on his back. In his right hand each clutched a seal harpoon, in his left a stone scraper. They represented Sedna and her attendant. After the two figures had been supposedly killed by the men of the village, they revived and prophesied the fortunes of the community during the coming year.

The Feast of Bladders was held to ensure good fortune in hunting. The *inua* or spirit of an animal was held to reside in its bladder. Among the Chukchees of Alaska a feast was held in the communal chamber of the village, at which the *angekok* pretended to charm the 'Old Woman' of the sea, by combing her hair and thus placating her so that she would send plenty of seals. Many *angekok* came to this feast, bringing with them the idols which they had been carrying round the villages and islands. It was held in a room illuminated by many lamps. Young men, wearing fantastic animal and bird hats made from wood or rushes, crowded into the communal chamber. They imitated the cries and movements of the animals they represented. Upwards of a hundred bladders, painted and decorated, which had been taken from animals killed by arrows, were hung up on cords. Four puppets made from wood: two partridges, a sea-gull, and an osprey with a human head, were all made to show their paces. The osprey shook its head, the sea-gull snapped its beak, and the partridges flapped their wings. In the centre of the room was a post

covered with green leaves, representing the Spirit of the Sea. At every new dance, reeds and leaves were set on fire before the bladders and the birds. The day's proceedings closed with a feast of food which had been previously dedicated to the Four Winds and the God of the Clouds. Next morning the festival was renewed, and on the evening of the final day the bladders were taken down and carried on painted sticks to the sea shore, by torchlight. They were then thrown into the water and prophecies about the success of the hunting season were made from the time they took to sink.

The Feast of the Dead gave great scope for the Eskimo genius for ceremonial. The relatives of the dead and the master of ceremonies and seven assistants gathered in the dance house. The eight leaders of the proceedings wore long sealskin gloves, with strings of puffin bills hanging about their breasts and arms. They were decked in elaborate belts nearly a foot in width, consisting of the pelts from the white bellies of unborn caribou, trimmed with wolverine tails. The women carried eagle feathers, and wore a narrow strip of white sable tied round their heads. Each family then seated itself behind its lamp and began a song recounting the virtues of its dead ancestry. A feast, a night's rest, and a sauna bath for the men of the village interrupted the proceedings, after which the villagers walked in solemn procession round the sepulchres of the dead, preceded by a drummer and singers.

The struggle to survive

The continuous pursuit of wild animals not merely provided the Eskimo with almost all his food, it also gave him that self-confidence which is indispensable for a good artist. A hunter who was prepared to tackle a walrus at sea, alone, could fairly be considered to have enough self-confidence. He was not to be daunted by attempts at any art project, however difficult it might seem.

Success in the chase gave the Eskimo standing in eyes of the community. He might assume the importance of a chief; he would certainly be served first at feasts and speak first at councils. Poor hunters were despised and ostracised. Nansen found the grave of one of these unfortunates in Greenland. He had always been mocked by the community for his poor hunting abilities. Eventually the scorn heaped on him daily became too great to bear. He became an outlaw, wandered far from the village, and lived in a cave. Then, when death approached he carefully walled himself up in his own grave.

The whole of Eskimo life was a prayer for success in the hunt. The Eskimo only had two fears, that his wife might be barren, and his family without food. Barrenness could be cured by the *angekok,* who brought babies from the moon, and slept with barren wives as part of his fee. Success in hunting was a much more chancy affair. The records of early explorers teem with accounts of bold, skilful communities of hunters reduced to starving in the darkness of their unlit houses. There is no game to be had. Some unknown factor, such as a change in the weather perhaps, has frightened away all the animals. The community can do nothing but suffer.

Amongst the Aleutians, whale hunters were assembled into special lodges or colleges. Only those who could pass a severe probation and who had the required skill and strength could be enrolled. Once a whaling captain had struck a whale with his lance, poisoned with aconite, he retired to an isolated hut, where he spent three days and nights without food or drink. Meanwhile he imitated the groaning of the wounded whale, trying to ensure its death by this magical ceremony. At the end of the three days he put out to sea again, hoping to find the whale dead as a result of the poison.

He would then cut out the poisoned flesh round the head of the dart, lest it harm those who were going to eat the animal's flesh. Like Voltaire, he believed that you could kill a flock of sheep with witchcraft, provided you used enough arsenic first.

A magical aura surrounded the whalers, at least while the whaling season lasted. They might not sleep with their wives, but on the other hand the unfaithfulness of their wives while they were away at sea would cause the worst of bad luck. No one might dare to eat their food, which was impregnated with magical virtues, nor approach them, or even look at their oars. Whaling was carried out by Central and Eastern Eskimos from *umiaks,* large skin boats with accommodation for several paddlers and a steersman.

For the Alaskans, whaling was a much more dangerous venture. It was carried out in Pacific and Arctic Alaska by attacks launched in two-man *kayaks* called *bidarkas.* The whalers tried to trap their prey in bays. In other parts of Alaska, whaling confraternities, were headed by whaling captains called *umialiks.* The crew camped on the edge of the ice, with their *umiak* poised ready to be launched. A whale which breached would then be harpooned by a skeleton crew, who would then return for the rest of the group, confident that the inflated sealskin floats on the end of the line would eventually force the wounded whale to the surface, where they, or other crews which had responded to their signals, would finish it off.

Not all religious practices connected with hunting were as elaborate as those of the Aleutians, but even the smallest piece of ornamentation — such as an ivory cut-out on a spear thrower — might not be just ornamentation, but a religious amulet to ensure good success in the chase. The seal in realistic or symbolical form appears again and again, a mute appeal for success in hunting that animal.

For the seal was the principal object of the chase. A Russian missionary, describing to an Aleut the joys of the Christian heaven, was rudely interrupted by him. 'What about the seals? You say nothing about seals. Have you any seals in your heaven?'

'Certainly not, what would seals do up there?'

'That's enough! Your heaven has no seals, and a heaven without seals cannot suit us!'

The hunter would usually approach seals during the summer at sea in his *kayak,* which was sometimes provided with a white screen in the bows to prevent detection by the animal. When close enough, he would hurl a harpoon at the seal, wait for it to surface, and then kill it with a lance before towing it home, buoyed by bladders. In autumn when the sea had just frozen, and the ice was smooth, he would follow seals on the ice on snowshoes and kill them before they could escape to the sea. In

31 An Eskimo hunter steals along in his *kayak*, looking for seal. A white screen in the bows helps to conceal his presence. He wields a double paddle, and in front of him, on a special stand, is the coiled-up line for his harpoon (Photo Danish Tourist Board)

winter a long, tedious wait on the ice by the breathing hole of a seal was necessary, until the seal blew away the light marker placed above the hole or betrayed its presence to the ear of the hunter, so that he could harpoon it through the tiny opening in the ice, enlarge the hole and drag it to the surface.

In Alaska seals were also driven into pens, being forced along the road to the pens by shouting and banging of clappers. They were kept in confinement by a few fluttering flags and flimsy ropes till they could be killed at leisure.

Walrus were speared at sea, or on the edge of the ice. Polar bears were attacked in the water, or on land, brought to bay with dogs, and lanced. A similar procedure was used against the formidable musk ox.

Caribou were driven into ambushes, killed while crossing rivers by hunters in *kayaks,* or shot with a bow and arrow. Birds were brought down by means of ingenious bird-darts,

which had ends which feathered into multiple darts and side prongs. They were also netted in snares, killed by bolas, or brought down by special arrows.

Fish played a large part in the Eskimo diet. It was caught with nets, hooks and lines, fish traps, and other means.

Nothing was so personal to the Eskimo as his hunting gear. He had made it all himself, to his own requirements. His life, and the livelihood of his family, depended on its correct functioning. The Arctic does not accept excuses for bad workmanship, and a man who was prepared to tackle a walrus single-handed at sea, in a *kayak,* with arms of his own devising, needed to have the greatest confidence in himself as a craftsman as well as a hunter. Otherwise he might not have the satisfaction of taking his equipment to his grave with him.

The harpoon was the prime weapon of the Eskimo. It

42

was a spear to which was attached, at the striking end, a barbed point of bone or ivory, tipped with flint, or imported copper or iron. Once struck, the harpoon head, which was often set on a toggle, would become detached from the shaft, and the angle of force at which it was being pulled between the line and the hunted beast would drive it further into the wound. A long harpoon line, coiled up on the *kayak* deck, on a special circular stand, ran out as the seal dived, struck by the harpoon. At the end of the harpoon line were two floats, made of inflated seal's intestines, which the hunter blew up by means of a bone tube. The buoyancy of the floats eventually dragged the seal up from its dive, exhausted, whereupon the hunter killed it on the surface with a lance of ivory with a flint head, or a long flint and ivory knife.

Bird darts and fish spears were rather like harpoons, except that their heads were fixed. Bird darts had front and side prongs which fanned out like a feather broom. If the front prongs missed a bird the side ones might still bring it down. These darts, and harpoons as well, were sometimes provided with bone feathers — strips of whalebone attached to the end of the dart to steady the flight. Missiles such as bird darts could be hurled by means of a throwing stick, a wooden extension to the arm of the hunter. The throwing stick was a board in which a groove had been cut, together with a shaped handhold which

enabled the hunter to grasp it firmly. The end of the spear was knocked into a notch at one end of the spear thrower, while the thrower grasped the other end of the board. An overarm turn of the hunter's arm sent the spear thrower flying forward, impelling the dart with much greater force than could have been achieved just by the hand. Throwing sticks were sometimes highly ornamented by a covering of miniature ivory cut-outs.

Once he had administered the death blow to a seal, the hunter would save its precious blood for soup by plugging the wound with a wooden peg with continuous notches cut round the side. Then he would float the seal by attaching it to inflated bladders and tow it home behind his *kayak*.

The shortage of wood in Eskimoland was compensated for by ingenious composite bows. These were made from deer's horn and sinews, and are very like bows used in Asia by the Mongol races in China, Japan, and Turkey. There was a large variety of specialist arrows. Bolas and slings were also used to bring down small game.

Hunters made use of ingenious decoy whistles, bird snares, and whalebone nooses for catching waterfowl. Fishing equipment was elaborate and well devised; it included stone sinkers and decoys, mussel scoops, ivory fish used as bait, gaffs, and a hand harpoon which was thrust in instead of being impelled from a spear-thrower.

Dress, decoration and design

Eskimo dress managed to fulfill several roles at the same time. It was functional, and provided splendid protection from the climate. All polar explorers, and most whalers were forced to adopt Eskimo dress, or some modification of it, such as sealskin trousers. Besides being highly utilitarian it was also extremely decorative. Early travellers were fascinated by the clothes Eskimos wore. Even nowadays when the destruction of many of the animals which provided the raw material for their clothing has brought about a severe modification of style, their dress is still decorative, and distinctively Eskimo, even though it is sometimes made with white men's materials. Dress distinguished the difference between the sexes well — no easy task when both had to be bundled up in furs. The long tail to a woman's coat enabled her to be instantly recognised — in consequence her life would be spared by raiding parties of Indians, or less frequently, by hostile Eskimo. It is not surprising that Eskimo clothing was superlative, considering that they had at their disposal the most sought-after dress material in the history of the world — furs. No one was a greater connoisseur of these than a hunter who had killed fur-bearing animals all his life. Many garments, which in old prints seem ordinary enough to us, relied for their decorative appeal on the fact that they were made from the rarest and most expensive furs obtainable, such as pelts of the white sable, which was so choice that it was traded for thirty beaver skins.

The Eskimo were pioneers of dress and developed at least one style which was to be copied by millions of people who had never heard of them, the *parka* or *anorak*, two words for the same garment, which are used interchangeably in this book.

Both men and women wore similar clothes, which did not vary much over the whole of the Eskimo territory. A wardrobe would include boots, trousers, and hooded *parkas*. Women wore bikini pants inside the house. All clothes were cut and sewn by women, who had to have a good set of teeth to chew the sealskins to the requisite degree of suppleness. This task would seem irksome to us, but less so to an Eskimo, who once ate hides when there was nothing better to eat.

Trousers were made from sealskin, caribou, or reindeer, squirrel, or polar bear pelts. The *parka* was cut with no opening in front, just like the smock frock worn by English farm labourers up to the nineteenth century.

Sailors also wore smocks, so perhaps this garment could have been derived from contact with Europeans. A *parka* had to be drawn over the head, and it had a rounded or pointed hood. It was made from two skins facing together. Trousers reached to below the knee and were tucked into boots of well-softened sealskin.

Outer *parkas* might be a raincoat of intestine and be extremely decorative, embodying stencilled or dyed leather trimmings, decorative fur, or ivory beads. Ornamental buttons set off boots and other articles of clothing, and later European trade beads were used in decoration.

Only in Alaska and the Aleutians did hats play a large part in dress, though Greenlanders wore the most elaborate eye-shades, often box-shaped and covered with ivory cut-outs. These shades were so substantial that they would have acted as visors, and warded off a blow aimed downwards at the face. Certain Alaskan types of hats are among the most picturesque of all items of Eskimo costume. The *umialiks,* or whaling captains, wore distinguishing hats, which were the badge of their office. These were made from pieces of sprucewood, softened by long immersion in the sea and steamed into a visor shape. The bent round hoop of the visor was fastened by sewing it at the back. The hat could take various shapes and different colours. Most often it was streaked with white and light blue, or even with yellow and red. Ivory ornaments were attached to the crest, and the back was garnished with a plume of feathers. The front bristled with the fur of a bear and the whiskers and moustaches taken from seals and sealions, whose muzzles had been carved on the hat with naive fidelity. Sealion bristles, which look so attractive when threaded through blue glass beads, but which seem such an unusual ornament, may have been adopted because they were considered precious. Certainly the Chinese prized them as prickers for opium pipes and were prepared to pay a good price for them.

Decorative hats were also worn by the Western Eskimos. They included those shaped like flowerpots, and also coolie hats, another reminder of how close the great civilisations of the Far East were to the heartland of Eskimo culture. These hats were woven from spruce roots with painted designs. Women wore hats made from woven intestines, shaped like a top hat.

Allied to the hat was the headband, another fashion of

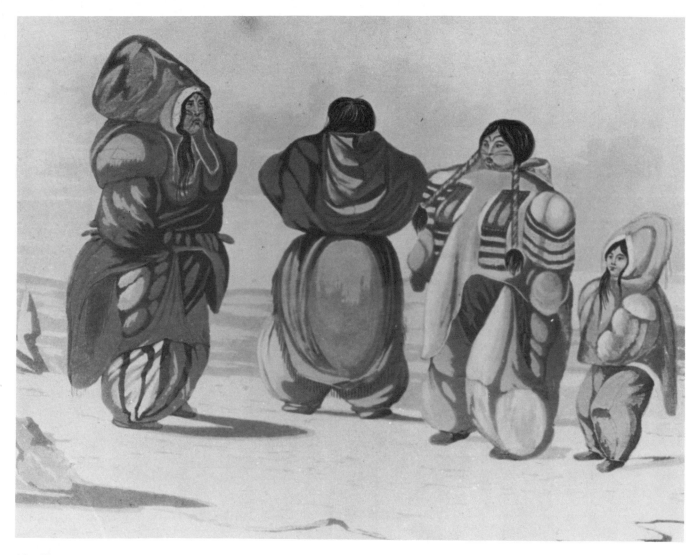

32　Women's dress at Igloolik, Canada. Note the decorative seaming in the trousers inlaid with darker or dyed fur, the beaded panels on the parka, the **multicoloured fringes**, and the swelling trouser legs. Sketch by Lyon, 1822

the Eskimos adopted by the Western World, and of course long in use by their Asiatic cousins, the Japanese. The headband had an undoubtedly useful function, in that it prevented hair from falling across the face or sweat trickling into the eyes. Nevertheless headbands were probably always principally decorative in intent. One worn by an Alaskan Eskimo in 1822 was heavily ornamented with beads. This article of dress continued in use till the nineteenth century. Women occasionally wore headbands of fur, ornamented with feathers for festive occasions such as the Festival of the Dead.

Although deprived of the use of metal, which was too precious to be employed for ornament, the Eskimo contrived very attractive jewellery from what materials they had on hand. They were able to pierce not merely the softer precious stones, such as amber and turquoise, but even harder pebbles. In Greenland elaborate buckles were

fabricated from ivory, pierced with tiny holes, and ornamented by rubbing pigment made from blubber and soot into the holes. Ornamental buttons of very attractive design were also curved from ivory. These appear not only on clothing but on the decks of *kayaks,* for fastening down hunting equipment. Beads were carved from ivory or bone, while the vertebrae and teeth of animals, carved or left plain, were also used for this purpose. Often the natural shape of a tooth would suggest its use for a bead, or a pendant. Very ingenious beads which linked together were also carved, two and two, from a single piece of ivory. Pendants of ivory were carved in human shape. Women wore beads and other jewellery elements in their hair, or on their hairbands. They also wore necklaces and earings of beads.

Nowhere was jewellery carried to greater lengths than in Alaska and the Aleutians. Cook describes the impression made on him by a crowd of Aleutians:

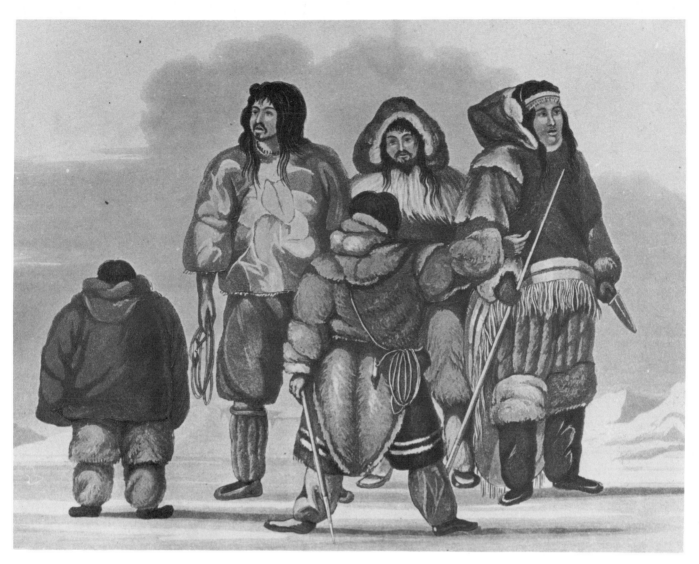

33 Men's costume. The man on the left wears a waterproof *parka* made of bird skins sewn together. The one on the right wears a hair band. Note the decorative trimming of dyed and contrasting fur and skin. Sketch by Lyon, 1822

Both sexes have the ears perforated with several holes, about the outer and lower part of the edge, in which they hang little bunches of beads. The septum of the nose is also perforated, through which they frequently thrust the quill feathers of small birds, or little beading ornaments made of shelly substances, strung on a stiff string of cord, three or four inches long, which give them a truly grotesque appearance. But the most uncommon and unsightly ornamental fashion, adopted by some of both sexes, is their having the underlip slit, or cut quite through in the direction of the mouth, a little below the swelling part.

The ornament which puzzled Cook so much was of course the *labret,* a little cylinder worn in the lower lip and made from ivory or mother of pearl. It must have been extremely uncomfortable to wear, as it made it impossible to close one's mouth. Nonetheless it was highly sought after, and many massive *labrets,* of all sorts of material, including very heavy ones of marble, have been discovered.

Nose ornaments, which Cook mentions, were made from bone or ivory, and beautifully carved. Porcupine quills were also worn in the nose.

Strings of beads, worn by both sexes, could be made from natural objects, such as puffin's beaks, amber, or pebbles holed with a sharp flint. Eighteenth century travellers found that beads were much in use for trading among Eskimos in Alaska and Canada. The blue glass beads were more appreciated than the white. They appear in dress as well as in jewellery. Alaskan hats sometimes have blue glass beads threaded onto the sealion whiskers which ornament them.

Paint was worn by some Eskimos. It was donned for a war raid by the Chugach in Alaska, and other Eskimos wore blue, grey, black or red paint on occasions. It has been suggested that this custom was not intended for adornment but to prevent the sea spray caking on the face of a seafarer.

Tattooing was also in use. Cook comments on Eskimo women 'puncturing or staining the chin with black that comes to a point in each cheek, a practice very similar to which is in fashion among the females of Greenland'. The custom of tatooing was probably most widely followed in Alaska, where at one time the Aleuts used to engrave figures of birds and fishes on their skins. Women wore tattoos recording the exploits of their families in war or hunting. Women tattooed the forehead, cheeks, chin, arms, hand, thighs and breasts, as well as wearing bands of tattoo which suggested the bikini pants which were the only garments usually worn inside the house. In Greenland a girl's best friend, or her mother, drew a needle and thread, which had been covered with the juice of marine algae and soot, under her skin, or pricked in the tattoo pattern with a needle dipped in the same mixture.

Men in Alaska often gave themselves a tonsure by clipping and shaving part of the head — no easy matter when only a flint knife was available to do it. This head shaving recalls the similarly shaved heads of other Mongolian races, such as the Japanese and Chinese. Eskimo women either wore their hair in two pigtails on each side of the head, or piled it up in a bun on top. The bun was held in place with a hair fastener resembling a miniature dog whip, the handle part acting as a stiffener to keep the bun erect, the whip end wound round and round the bun to produce a neat finish. Amulets could be worn inside the

34 Eskimo women and children at Igloolik in Canada. Note the deep fringing of their garments; also the women's tattoo marks and hair styles. Drawn by Lyon, 1822

bun, and it was often ornamented with beads. Both sexes occasionally wore hair bands.

All Eskimo decoration — even extraordinary pieces such as the ivory masks of Ipiutak — can be classed under just a few principles of design.

Decorative devices include plugging, drilling a hole in ivory or bone, and filling it with a plug made of some darker material. At Ipiutak the hole was filled with jet, a perfect contrast to ivory, and eyeballs for skulls and funerary masks were made in this way. It goes to show how persistent ideas are in Eskimo art, that plugging was still being used in quite modern times, on cribbage boards made for white patrons. In this case, however, it was only the eyes of animals which were plugged, this time not with jet, but with dark horn.

Allied to plugging is spotting. The even distribution of darkened spots was one of the stand-bys of Eskimo decoration. Dots were used as tattoos for women, and dotted patterns were engraved in ivory objects. The dots were arranged regularly, sometimes in parallel lines. Once dots had been drilled into a piece of ivory, they would be filled with oxidised whale blubber mixed with soot. This would act as a permanent pigment. Again the worldwide distribution of this decorative device is amazing. It was found on the ivory head of a casting lance discovered by Jochelson in extremely old deposits on the Aleutians, and it appears regularly on toys, religious objects, combs and other works of art collected in Greenland in the nineteenth century.

Closely connecting with spotting is the spot and circle pattern. In this case the spot was probably drilled in first and then the circle drawn round it. In Ipiutak, where the spot and circle motif first appears, it has been suggested that iron compasses were the tools which enabled this kind of ornamentation to develop. However, spot and circle ornamentation appears to have been cut by Eskimos who did not possess iron compasses — a very advanced tool for an Eskimo to own, incidentally — and there is no reason why they should not have been inscribed by a prong operated by hand, or by the bowdrill. One prong, a bone tip, would fit into the drilling hole. The other, armed with a flint or quartz point, would inscribe the circle. The spot and circle pattern was so widely used in Eskimo art that it can be said to be characteristic of the Eskimo. It is one of the many links which seem to establish some sort of connection between them and Stone Age Man: there are, for example, spot and circle cave drawings, which were made by Stone Age hunters, in the cave of Mwalamolemba, in Malawi.

The cut-out or silhouette figure is also widely used in Eskimo art. It appears, for example, in the representational figures in scrimshaw, where it is only the silhouettes of caribou, hunters or *umiaks* which appear, never an outline figure with details.

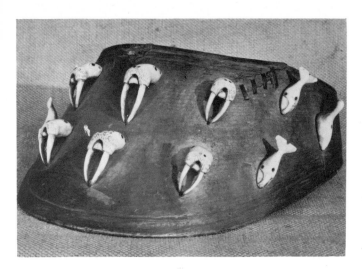

35 Hat brim from Alaska, made of spruce wood ornamented with ivory figures of birds, walrus and whales. Note the eyes plugged with blackthorn and the scrimshaw decoration (Photo British Museum)

Cut-outs appear in embroidery, on skin pictures and on bags. Representational cut-outs carved out of ivory are used to decorate woodwork of any kind, spear throwers, water buckets and so forth. Seals, narwhals, white whales, bears, birds, fishes, men, and *kayaks* were represented in these low relief figures of ivory or bone.

Symbolic cut-outs can be derived from the realistic ones. Thus two seals touching noses appear as an hour glass figure. Sometimes an ornament of this sort was of a purely symbolic nature. A *tornarsuk* would be represented by a squat, monstrous figure, with a diminutive head, while a low crab-like figure would stand for an *aperketek*.

Realistic carvings were almost always faces, or masks, or animals. There is, of course, figure-carving in its own right, but this is not design. The face, single or in combination, appears again and again in Eskimo art. *Inersuak* faces, carved with a face on each side of a block of wood carved in Greenland in the nineteenth century, can be parallelled in modern Canada.

Broken line and parallel line decoration are as old as Eskimo art itself. They occur on the 'tridents' of the Punuk people. These objects have long puzzled archaeologists, just as the 'winged objects' of the Old Bering Sea People. Surely there can be no possible explanation for both kinds of ivory carvings except to assume that they were counterbalances for spear throwers, those which were shafted rather than board-shaped? A glance at the remarkable similarity between these objects and the 'bird stones' of Indiana, which are similarly shaped, and also pierced at the centre, and which we know to have been counterbalances for spear throwers, will establish this connection. It is worth mentioning that not only do the Old Bering Sea objects include broken lines, they also have spot and circle decoration which is drawn free-hand, showing how closely linked is Eskimo decoration.

Broken line decoration and parallel line decoration was treated in various ways. Sometimes the parallel lines were broken up by chip carving, sometimes a V-shaped line connected them, sometimes lines branched off from them or within them, like Ogham lettering.

Geometrical designs also have a long history. They appear on Punuk carvings, though there they are less stiffly geometrical than in Thule scrimshaw or on ancient Aleutian *labrets.*

The skeletonised decoration of some Eskimo ivory carvings, about which so much has been said, has, I feel, been misunderstood. The lines on some 'skeletonised' piece, such as the baby walrus from Point Hope, do not in fact represent real anatomical divisions. One subject which an Eskimo knew backwards was animal anatomy. He could name every organ in an animal, and he expected to receive some particular portion of a kill when it was broken up. If these were skeleton markings they would, I feel, have some relation to reality. Furthermore there are human figures which are skeletonised as well, such as an ivory doll of the Western Thule culture found at Cape Krusenstern. What we have here is either an attempt to imitate tattoo marks, or the usual Eskimo fondness for scrimshaw, which has to appear everywhere, even on figures.

Eskimo women played an important part in the community. It was their job to prepare skins and make up clothes. Both for protection from the cold and for transportation, their menfolk depended on their skill with scraper, teeth, and needle. The fact that the Eskimo woman had a comparatively high status in her family, hedged about though she was by convention and taboo, reflects her important role as the producer of covering material for man and boat alike.

All sorts of allied arts entered into tailoring: cutting up decorative fur into strips and insetting it in garments, dyeing and inlaying pieces of coloured hide or eider duck plumage, and colouring those materials with stencils. Their work included embroidering with beads, and making skin pictures. These are made by sewing cut-outs, made from black sealskin, onto a bleached sealskin or caribou background. Many of these cut-outs depict familiar objects, such as woman's knives, gloves, combs, birds, animals, and mothers with babies. The artist conceives the whole design in her mind before she starts work. Next she cuts out the objects without drawing out a preliminary pattern, or even without marking them out on the sealskin. The Eskimos, as mentioned earlier, have an extraordinary eidetic vision. Once they have looked hard at something, its form and proportions remain fixed in their minds. If they want to make a set of clothes for someone, all they need to do is to look at him, no measurements are required. Besides making pictures for them, women artists used sealskin cut-outs to decorate a wide variety of articles, including sealskin bags.

Where the materials for basket-making were available —

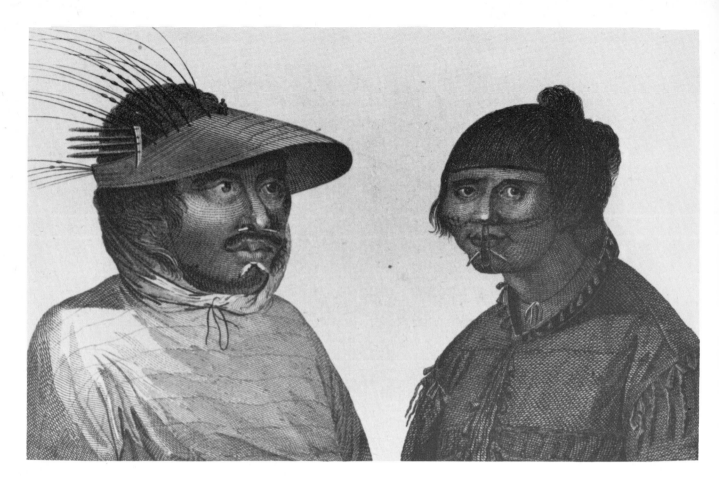

36 Man and woman of Alaska, as seen by Cook. Note the man's mask of bent spruce wood ornamented with sealion bristles, his lip and nose ornament, and his raincoat of intestines. The woman wears a buckskin jacket with fringes and a neck pendant (which may be an amulet), and is heavily tattooed; she too wears a labret

as in Eastern Canada for example — Eskimo women made elaborate coiled baskets. Strips of sealskin and whale sinew were woven into the baskets to give relief.

The heavy work of preparing enough skins to cover a *kayak* or an *umiak* must have occupied much of the productive energies of the women of the village. They cooperated in large-scale ventures, such as covering boats. A woman's reputation depended on the tightness of her husband's *kayak* cover, and if she failed to do her job properly she would be made the laughing stock of the community through satirical drum songs.

Other women's arts included ivory carving, possibly with particular reference to those items which were peculiarly woman's gear, needle cases and combs. Women also made extremely decorative bags from all sorts of original materials, such as fish heads.

37 Today Maria Thomas of Fort Yukon, Alaska still works on a caribou skin (Photo Bernadine Bailey)

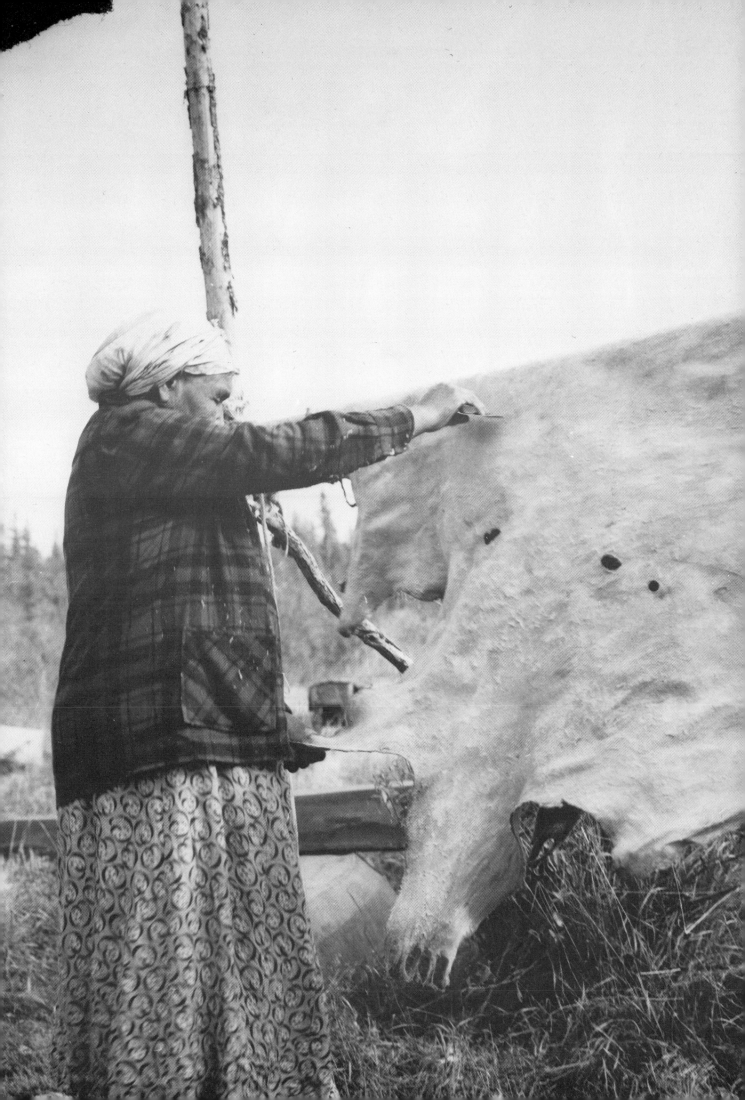

Modern art

There is nothing particularly new about modern Eskimo art. The first explorers to settle for any length of time among the Canadian Eskimos found that they could draw perfect freehand maps of the areas in which they lived. Some of these maps were reproduced in nineteenth century works. Before 1867, an Alaskan Eskimo called Kriukof was painting excellent portraits in distemper. Chamisso, the Russian naturalist, was able to make out nine species of dolphins and whales in the paintings drawn by Alaskans.

The fact of the matter is that the Eskimo is a natural man, in whom the layers of diffidence which overlay the natural artist in Europe are absent. He exemplifies Eric Gill's contention that everyone could be an artist, if only he had the nerve. So when we speak of modern Eskimo artists, we are talking not about people of a peculiar talent, but rather such Eskimos as have chosen art as a means of making a living rather than, say, hunting, or working on a shrimp boat.

It is incredible what a variety of media Eskimos had explored before 1900. They had written manuscripts about their traditions, which they illustrated themselves. Under the influence of Dr. Rink, a bedridden Eskimo called Aaron had begun wood engraving, first drawing pictures of Eskimo legends, and then engraving them on wood. In 1861 Rink started an Eskimo paper called *Atuagagdliutit* in Godthaab in Greenland. An Eskimo, Lars Möllar, went to Copenhagen to learn lithography and then drew illustrations for the paper which he printed himself.

Although nineteenth century savants such as Elie Reclus told their readers that they would find a rich field of connoisseurship in Eskimo engravings, the time was not ripe. Europe and America were still digesting the impact of Japanese art, and the taste for the primitive had still to be established. The only art objects commissioned from the Eskimos were carvings and scrimshaw. In Alaska, an artist called Happy Jack achieved fame for his meticulous scrimshaw. He could even reproduce with miraculous accuracy the whole design of a Pear's Soap label. Neither the design nor the product represented traditional Eskimo taste, but most of the objects made by Eskimos showed their local origin, even though they might be cribbage boards or parasol handles.

Henry W. Elliott describes how the production of ivory curios was organised in one part of Alaska in the 1880s:

Down here at Nooshagak the natives have earned a distinction of being the most skilful sculptors of the whole northern range. Their carvings in walrus ivory are exceedingly curious, and beautifully wrought in many examples. The patience and fidelity with which they cut delicate patterns from walrus tusks furnished them by the traders are equal in many respects to that remarkable display made in the same line by the Chinese. Time is never reckoned, and it does not raise a ripple of concern in the Innuit's mind when, as he carves upon a tusk of white ivory, he pauses to think whether he shall be six hours or six months engaged upon the task. Shut up as he is from December until the end of February in his dark and smoky hut, he welcomes the task as one which will enable him to 'kill time' most agreeably, and bring in a trifle at least to him from the trader in the way of credit or of direct revenue.

The Alaskan school of Eskimo art may be said to have gone on flourishing, in a quiet way, since Alaska became American. It is characterised by forceful small carvings in ivory, sometimes mounted on baleen bases, with painted heads and eyes, by very talented water colour and oil drawings, and by well finished examples of women's art — *parkas,* slippers, etc. One of the advantages which the Alaskans possess is an inexhaustible wealth of ivory. Whereas the Canadian Eskimos have to import African ivory, and the Greenlanders have to get whale's teeth imported from Iceland, the Alaskan merely has to dig down to find frozen mammoth tusks.

Another advantage is that the Alaskan is capable of assimilating the models and influences given to him by his white patrons. The figure of the Chinese Buddha, for example, which began to be called for at the start of the twentieth century, is now not the least like anything Chinese, but is distinctively Eskimo.

In Canada, thanks to the influence of Canadian administrators and missionaries — not to speak of the Mounties, whose benevolent care for the 'nomads of the North' is mentioned by one Eskimo print-maker — art and crafts began to develop as part of the pattern of settled life. For many Eskimos, artistic production was an occasional outlet, often forced upon them by periods of unemployment or a bad hunting season. Success breeds success however, and the renown of Canadian Eskimo artists has become so great that many artists are probably now motivated by the desire to become world famous, rather than just make a little pocket money.

53

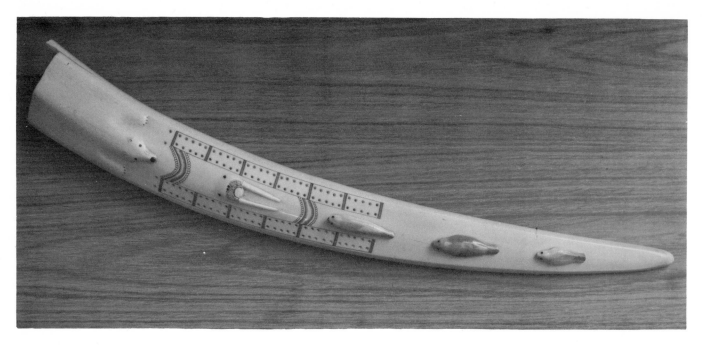

38 Cribbage board made in Alaska. It is ornamented with a bear, a walrus and seals with black plugged eyes; these are left in relief while the rest of the tusk had been laboriously chipped away (National Maritime Museum, Greenwich)

The first stone-cut prints were made in 1959, when government administrator James Houston introduced the Eskimos of Baffin Land to the techniques of stone-cut and stencil. Stencils had of course been used before by Eskimo women for decorating skins for clothing, and soapstone was a familiar material. The Cape Dorset Eskimos, among whom the 'Eskimo Renaissance' began, started by making prints as a cooperative venture. One drew the design, another cut the engraving plate, and a third would do the printing. This cooperative spirit has never been lost, and is now emphasised by mutual criticism and weekly meetings to discuss production. Soon the Cape Dorset Eskimos had set up their own cooperative to buy raw materials and tools, carry out print-making and market their products. A Canadian Eskimo Art Committee was set up in 1961 to advise on design and technical problems and to control quality. Individual seals were devised for the artist, the engraver and the printer.

Other print-making centres developed, among them Baker Lake, Holman Island and Povungnituk. Eskimo print-making is marked by traditional themes, often depicted with a conscious archaism. Many of the activities depicted in the prints are either completely obsolete, or becoming out-dated very quickly. Nobody, I suppose, now hunts with a bow or arrow, or sails in an *umiak* if there is a boat with an outboard motor available. In contrast to the hunting themes, the spirit figures are frighteningly real, while as depictors of animals, birds, and fish, the Eskimo print-makers leave nothing to be desired. Certain of them have put their stamp on the objects they portray. No one who has ever seen an owl print by Lucy, for example, will

ever look at a picture of an owl again in quite the same light. The naivety of the prints is accompanied by very sophisticated use of characteristically Eskimo decorative forms — such as the employment by Pauta of Baker Lake's splashes of colour arranged in little dabbing strokes.

The first copper engraving was made in 1961 by Kiakshuk. Copper engraving and line etching have many advantages over stone printing. A stone print must be rubbed onto the stone plate by hand. If it were pressed on it it would break the stone. Soapstone is easy to carve — and also very easy to miscarve. The soapstone plates have to be extremely thick and heavy, a disadvantage when many print-makers are women. Moreover in copper engraving an artist can work directly onto the plate without having to have his design transferred on to it. Prints made from copper plates can be printed in a press and stored much more easily then stone ones.

The faces of the print-makers, whose smiles are better equipped with good humour than teeth, speak more eloquently of their hard lives than do the brief biographies which they often append to their catalogues. Many of them divide their time between art work and other jobs, such as hunting or interpreting. Women have more time to devote to print-making than men. Some of these artists have known broken families, the early death of close relatives, wandering and privation. There is no stimulus to art so good as being really hard up, as Edmond About remarked, and for many of the engravers, print-making has been an alternative to starvation.

Many of the Canadian Eskimo artists have become household names: Parr, master of the animal print, Lucy,

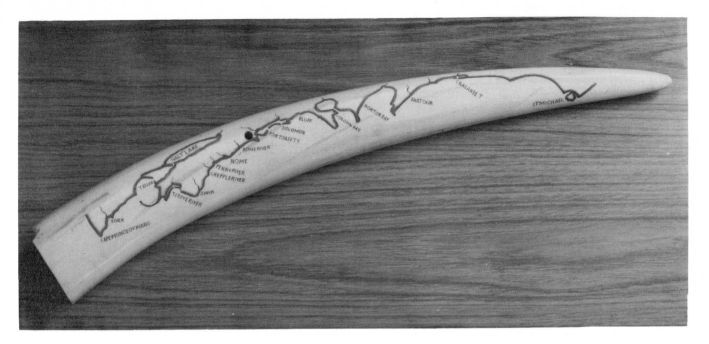

39 The other side of the same tusk, scrimshawed with a map of part of Alaska

Kiakshuk, Kenojuak, a woman artist who specialises in owls, Pudio, Pitseolak, a versatile portrayer of birds and animals, and Jamasie, are all from Cape Dorset. Baker Lake engravers of renown are Anglosaglo, Martha Noah, Seeroga, and many others.

Although it is one of the youngest art forms in existence today, some admirers of the Eskimo print already regret the 'good old days'. The proliferation of different colours and tectures in more modern prints has made them gayer, but has done something to rob them of their immediate impact. Sometimes they have become fussy and mannered: the original simple basic image has disappeared, to be frequently replaced by a multiple and complex one. But in spite of these doubts about the future of the Eskimo print, there can be no question that it is a form of art which is going to survive and grow. Every year there seem to be more and more exhibiting print-makers (thirty-four at Baker Lake alone in 1971). Unlike the soapstone or ivory figure, the print is easy to fit into a modern decor.

Compared with the Canadian artists, those of Greenland are unorganised and left much more to their own devices. Nowadays they are forced to get their ivory in the shape of imported whale's teeth which originate in the Icelandic whaling part of Kvalfördur, a narrow islet-strewn fjord fifty miles north of Reykjavik. Apart from a few which are secured by Icelandic artists, most whale's teeth are carried over, a car load at a time, by air to Kulusuk in Greenland. where the best carving is done. Kangamiut and Upernivik were also important centres until quite recently.

The principal outlets for the Greenland carver are the *tupilak* and the soapstone figure. The *tupilaks* have a bite to them which is not present in the more facile soapstone because of the demands of the material in which they are worked, a raw material made all the more difficult because of the very large hollow in the centre of the whale tooth. Ivory jewellery consisting of necklaces, pendants, earrings and lapel brooches are also made. Some of these are crude, but some show a very spirited vitality. Soapstone is carved into the shapes of animals, hunting scenes, and miniature cooking pots and lamps. The 'dream figures' of some of the carvings have been given a matt black finish with white projecting ivory teeth and nightmarish faces. Fur goods, such as *anoraks,* mittens, and dolls, are also made, together with models of *kayaks*. There is no national association of Eskimo carvers and artists in Greenland, as there is in Canada, and to get in touch with the artists themselves it is necessary to take a trip into the interior.

40 Skin picture by Keakjuk, a modern Canadian Eskimo. The figures are of black sealskin, cut out and sewn onto white hide

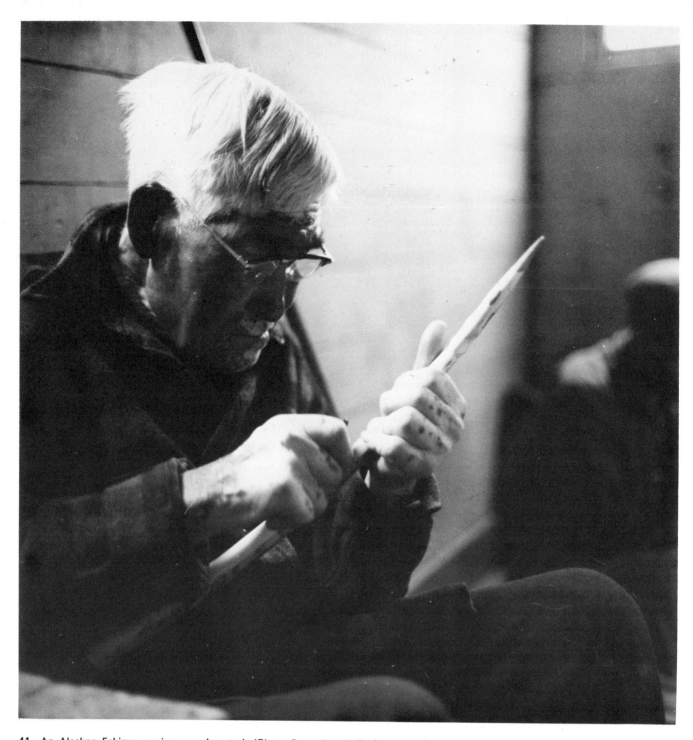

41 An Alaskan Eskimo carving a walrus tusk (Photo Bernadine Bailey)

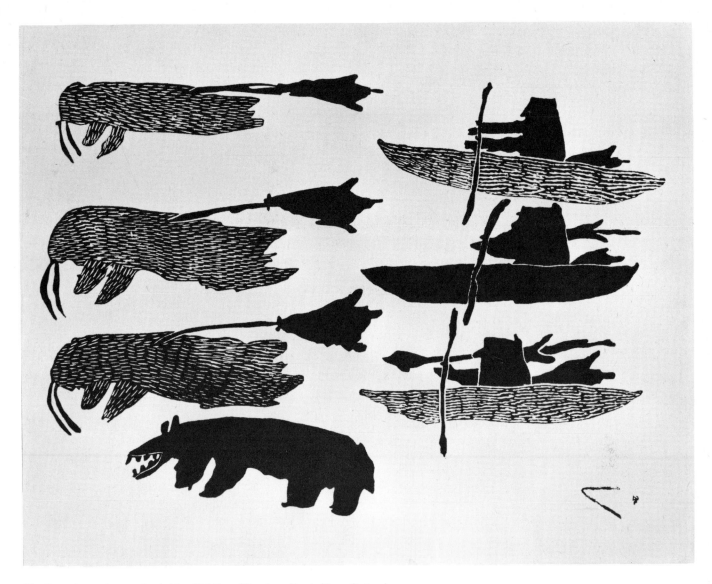

42 Soapstone stone-cut print by Old Parr (Courtesy Hugh Moss Gallery)

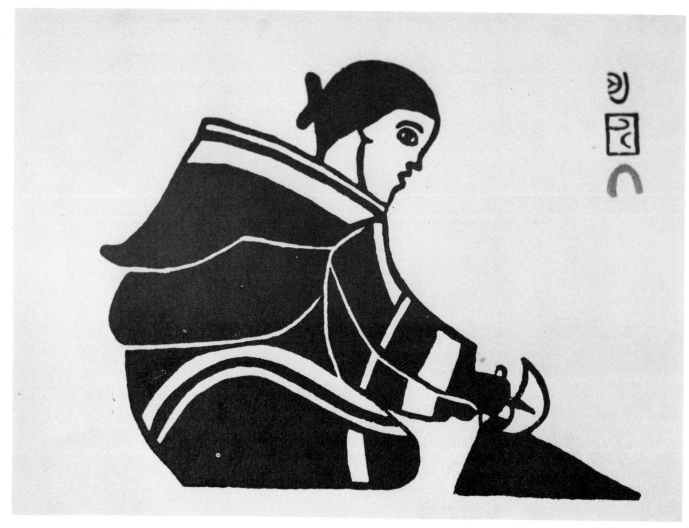

43 *Woman scraping board*, stone-cut by Pootagoot, Cape Dorset (Canadian Arctic Producers Ltd)

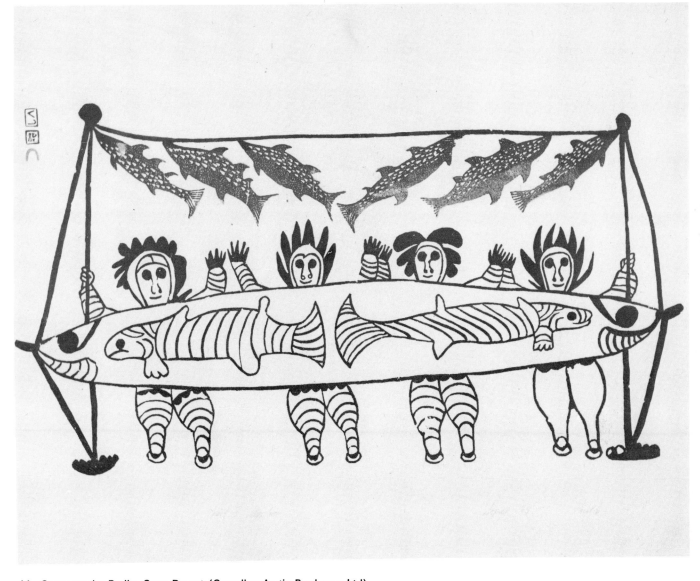

44　Stone-cut by Pudlo, Cape Dorset (Canadian Arctic Producers Ltd)

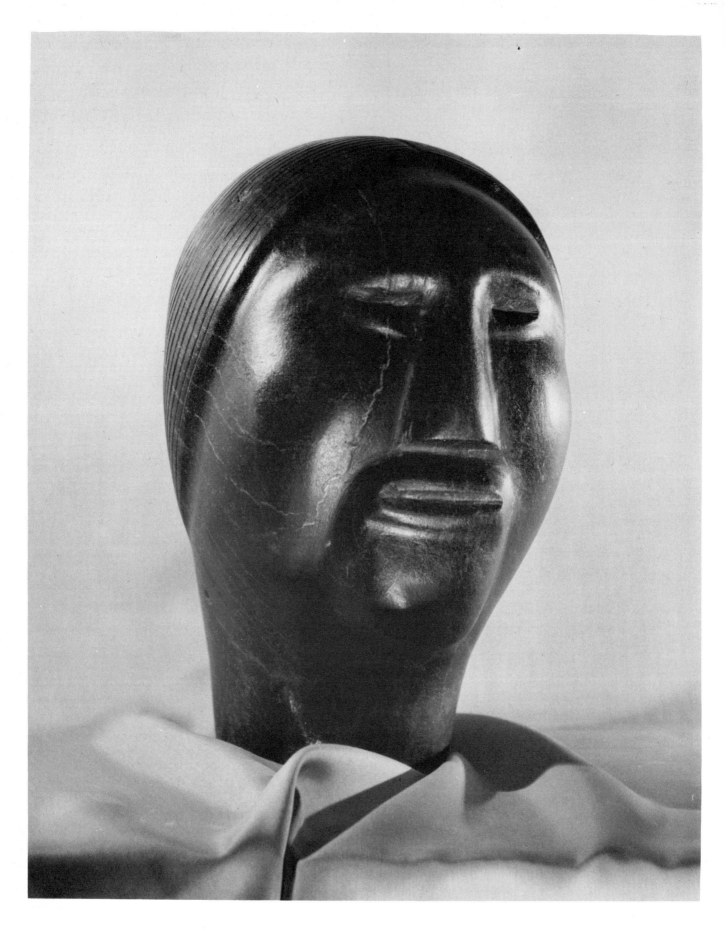

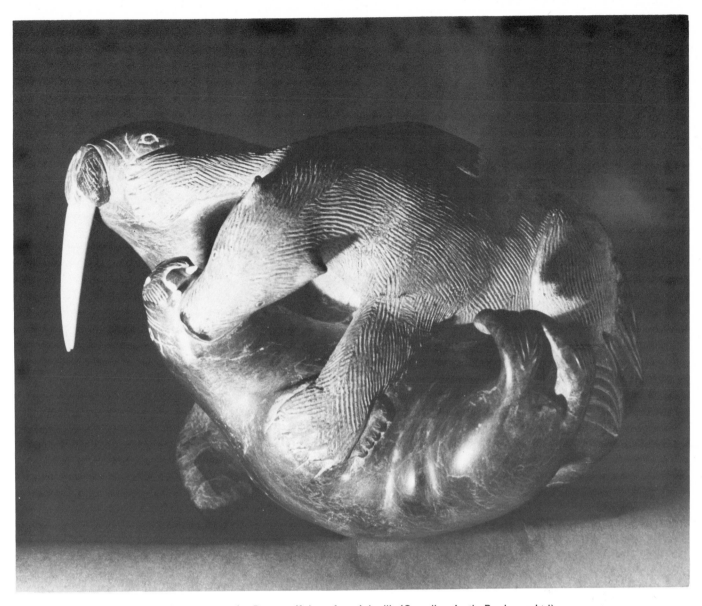

46 Modern Canadian carving in soapstone by Pacome Kolaut, from Igloolik (Canadian Arctic Producers Ltd)

left
45 Modern Canadian soapstone head by Erkolik, from Rankin Inlet (Canadian Arctic Producers Ltd)

overleaf
47 Modern Canadian carving of a woman and child by an unknown artist from Rankin Inlet (Canadian Arctic Producers Ltd)

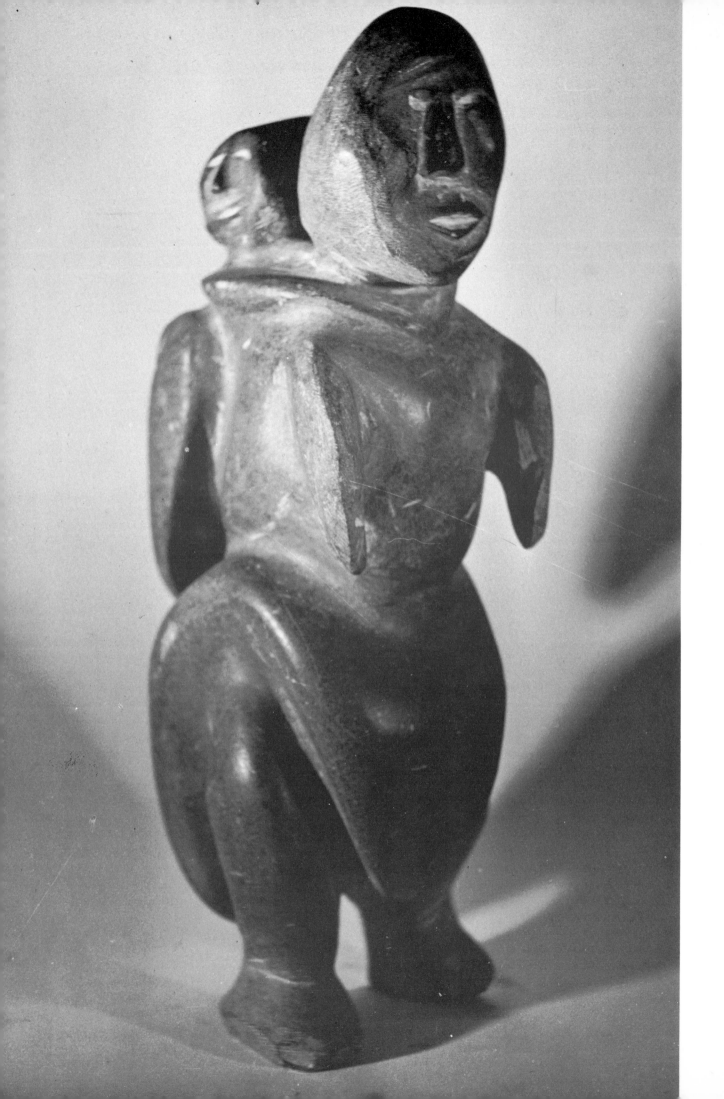

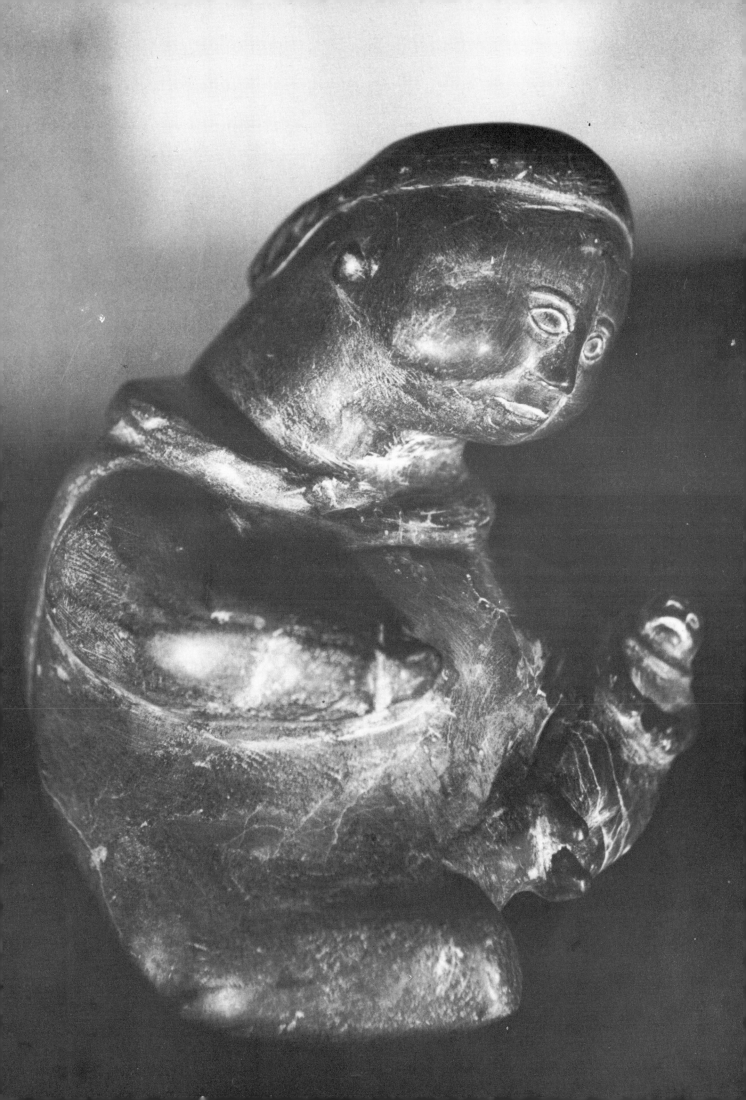

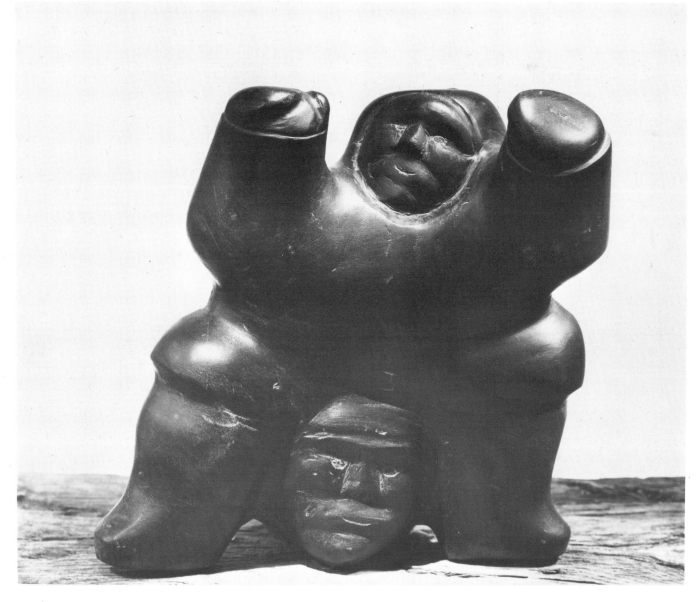

49 Modern Canadian carving in soapstone by Ekoota from Baker Lake (Canadian Arctic Producers Ltd)

previous page
48 Modern Canadian carving of a woman and child by **Arnaakata**, from Frobisher Bay (Canadian Arctic Producers Ltd)

right
50 Modern Canadian carving in whalebone by an unknown artist from Pangwirtung (Canadian Arctic Producers Ltd)

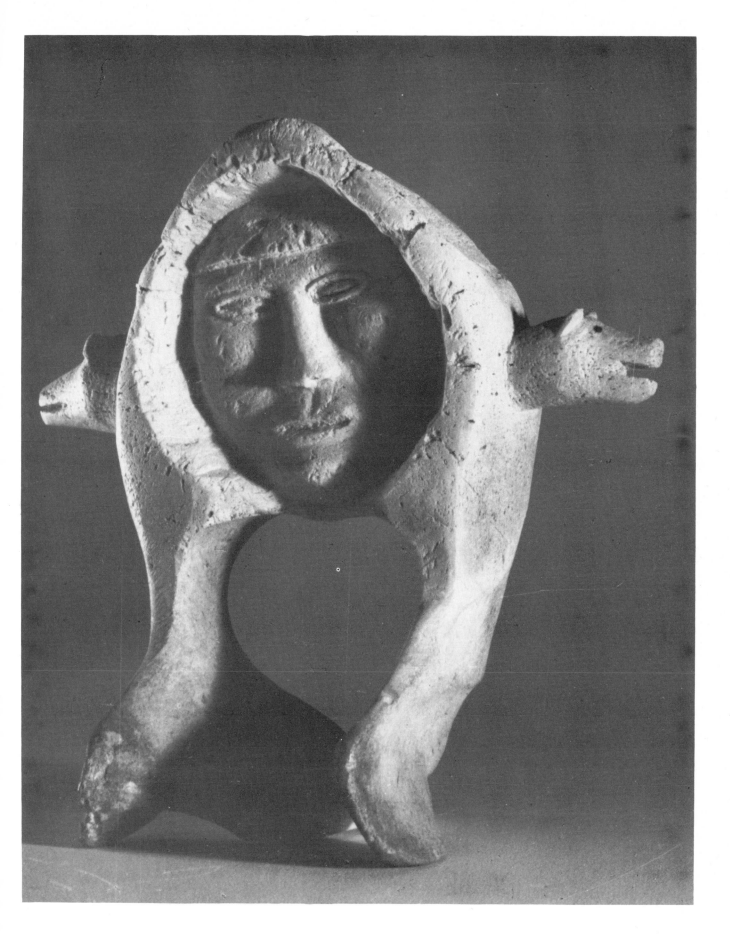

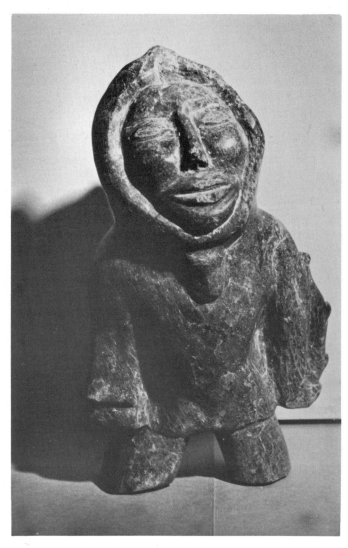 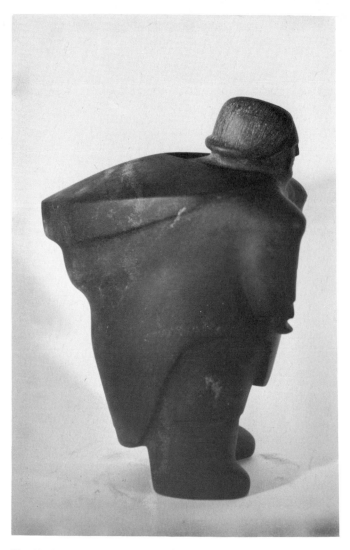

51 Modern Canadian soapstone carving by Tikito, Cape Dorset (Canadian Arctic Producers Ltd)

52 Modern soapstone carving of a woman from Baker Lake, Canada by Tattener (Canadian Arctic Producers Ltd)

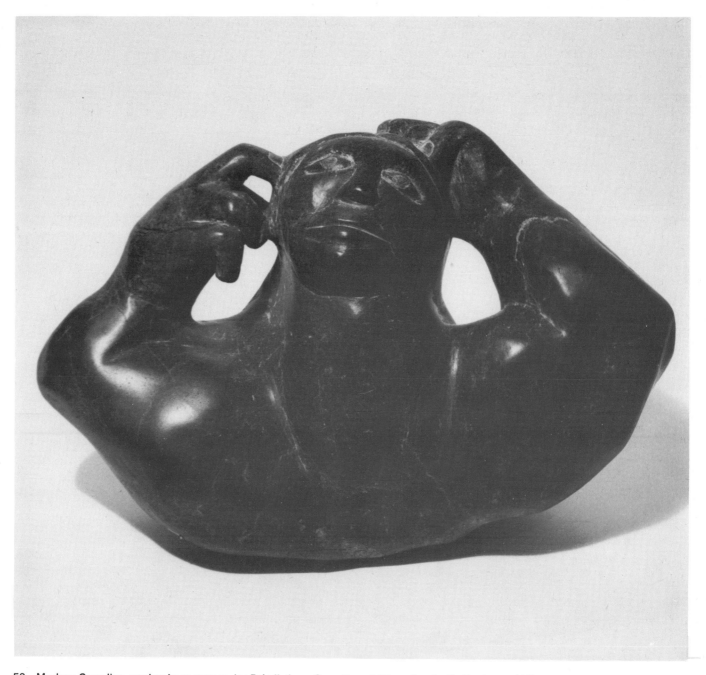

53 Modern Canadian carving in soapstone by Epirvik from Cape Dorset (Canadian Arctic Producers Ltd)

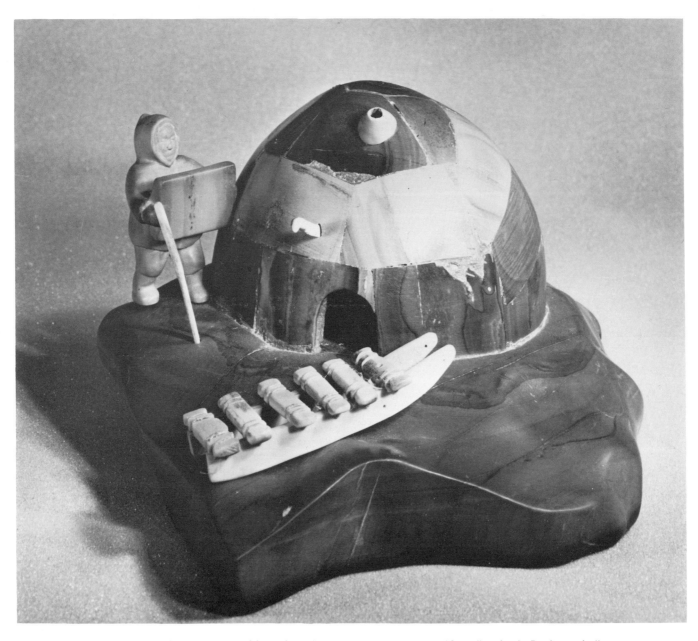

54 Modern Canadian carving in soapstone and ivory from Arctic Bay, artist unknown (Canadian Arctic Producers Ltd)

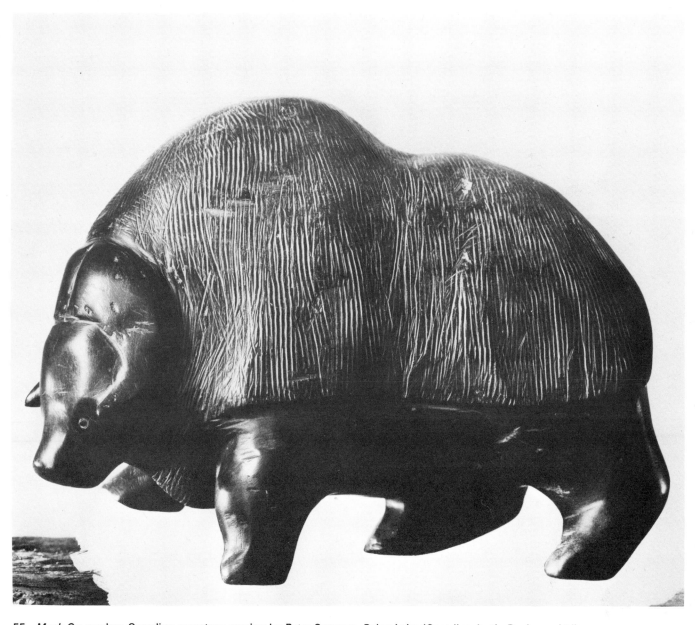

55 *Musk Ox*, modern Canadian soapstone carving by Peter Seenoga, Baker Lake (Canadian Arctic Producers Ltd)

overleaf
56 Modern Canadian carving in soapstone by Davidu Kagvik from Great Whale River (Canadian Arctic Producers Ltd)

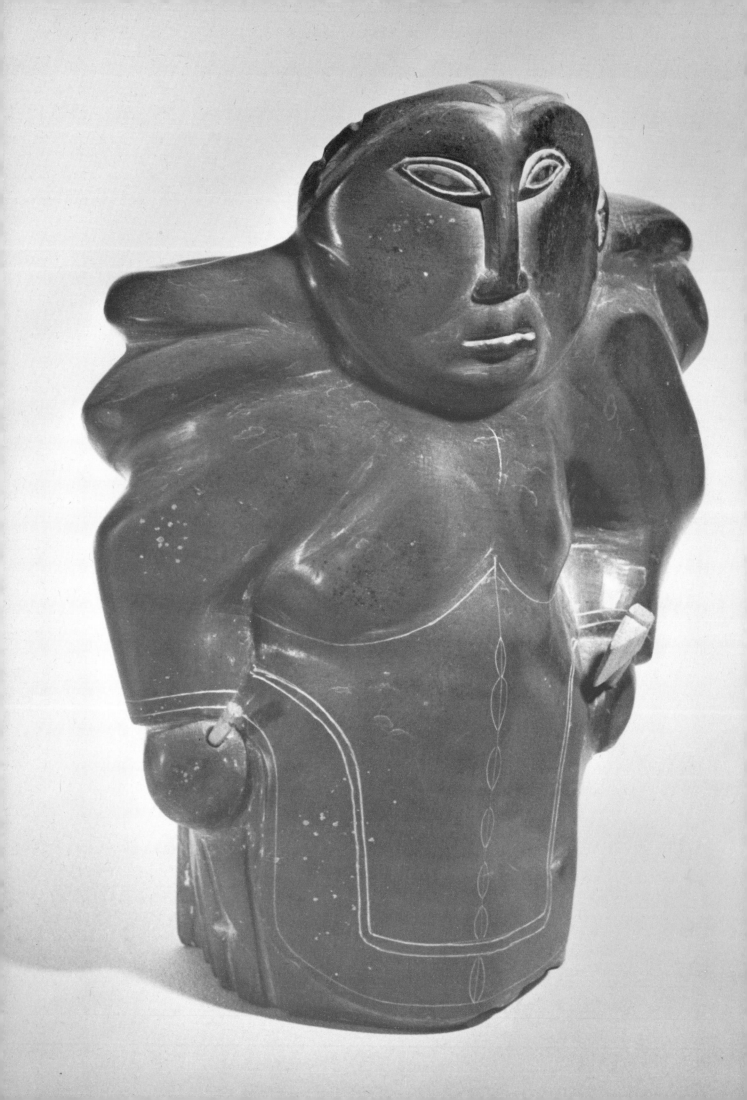

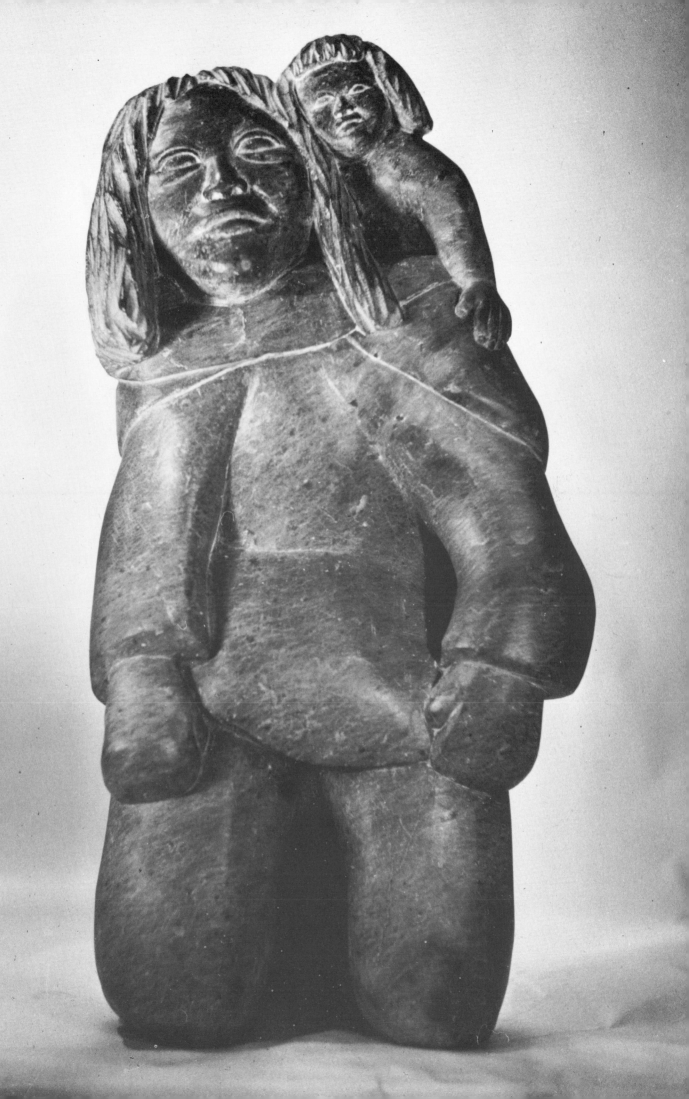

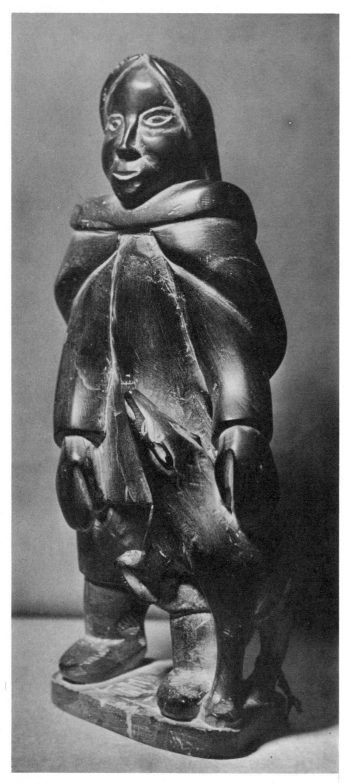

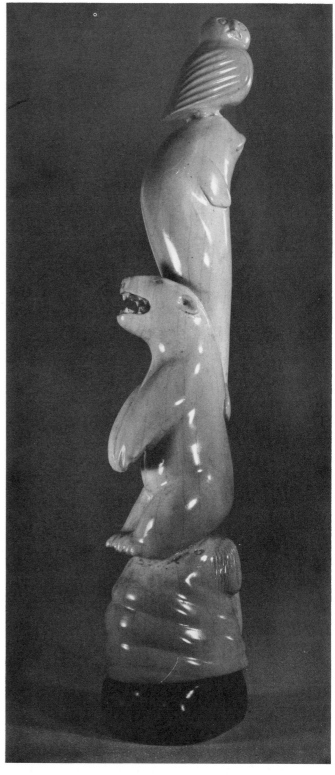

58 Modern Canadian soapstone carving by Mumamee from Frobisher Bay (Canadian Arctic Producers Ltd)

59 Modern Canadian ivory totem, from the Pond Inlet area. Artist unknown (Canadian Arctic Producers Ltd)

previous page
57 Modern Canadian soapstone sculpture by Kiawak, from Cape Dorset (Canadian Arctic Producers Ltd)

right
60 Ivory figure of a woman smoking a pipe. Note the topknot hairdressing. Greenland carving, probably from Kulusuk (Photo Stella Mayes Reid)

72

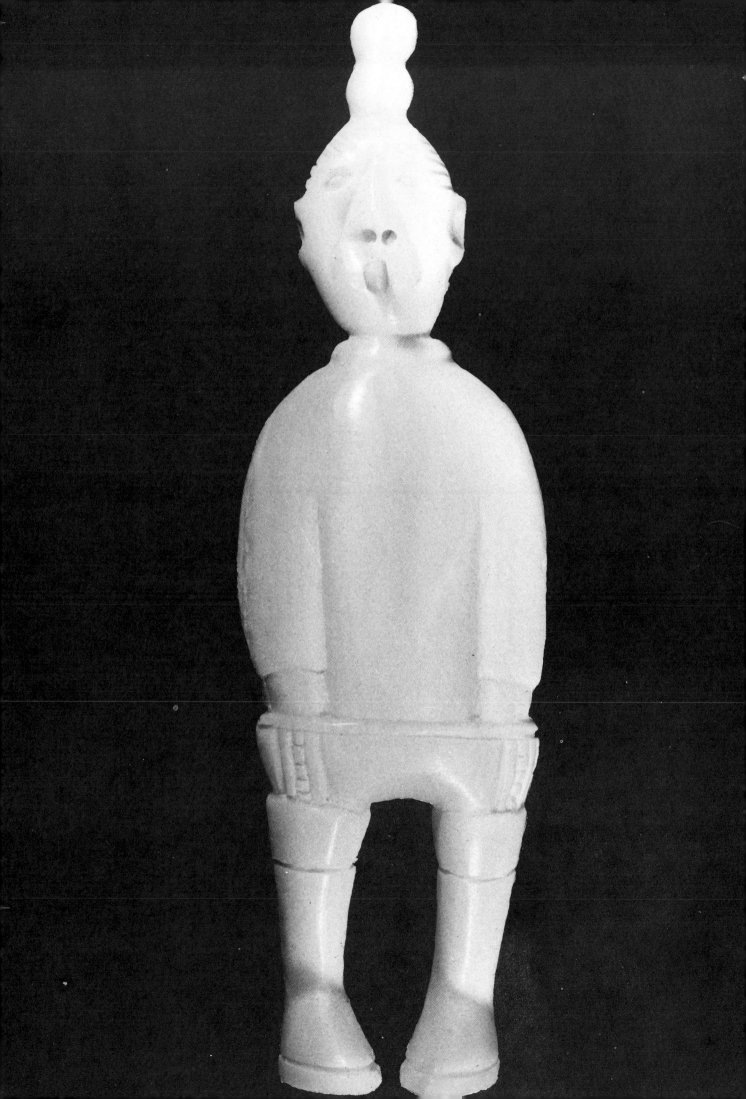

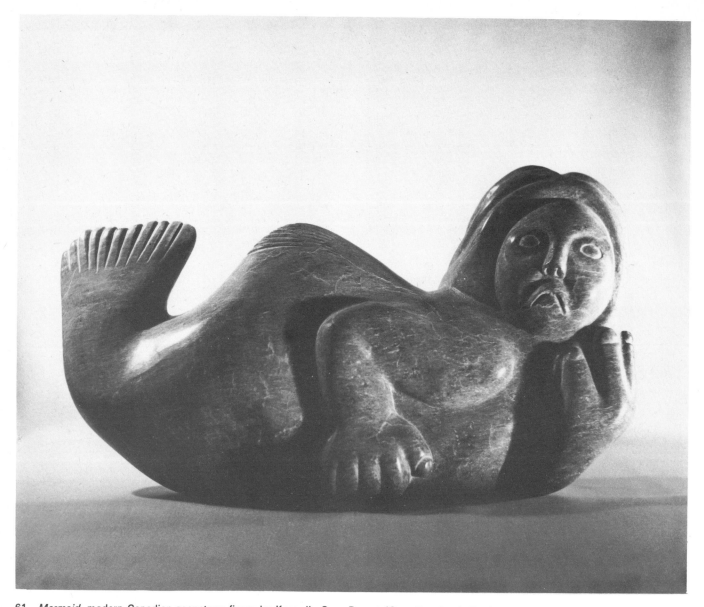

61 *Mermaid*, modern Canadian soapstone figure by Kopapik, Cape Dorset (Canadian Arctic Producers Ltd)

62 Modern Canadian soapstone sculpture by Osowetok, from Cape Dorset (Canadian Arctic Producers Ltd)

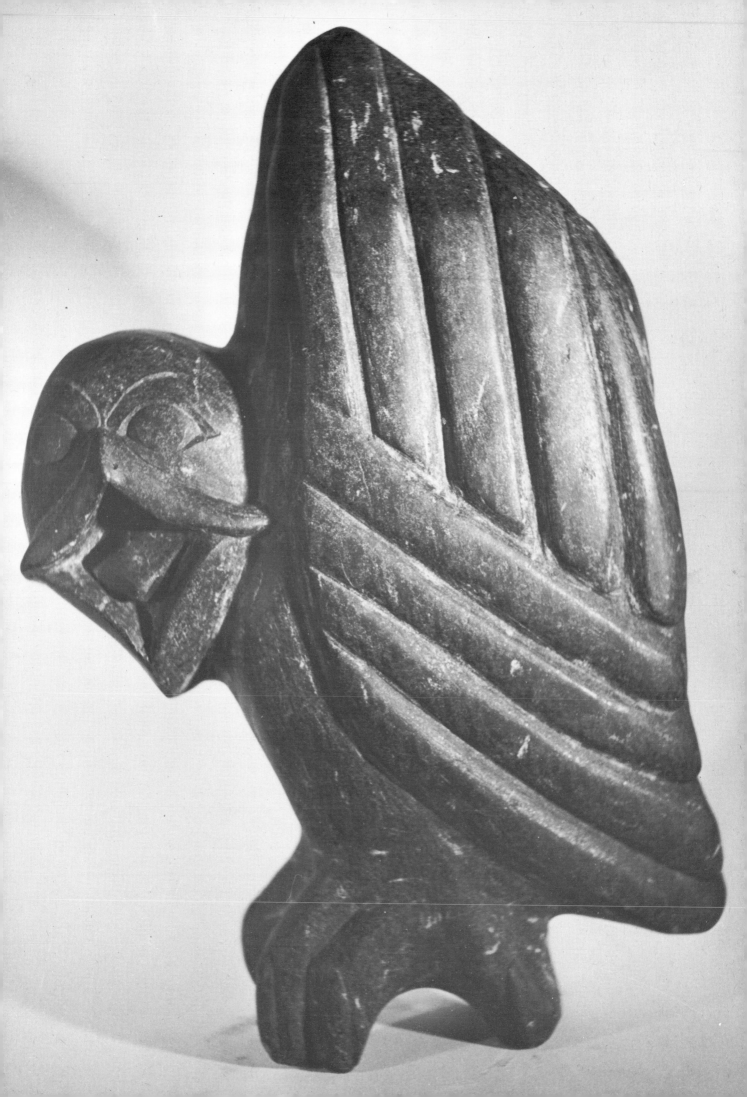

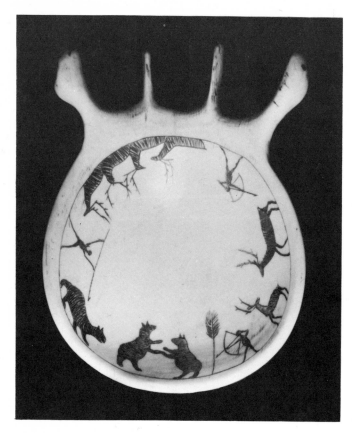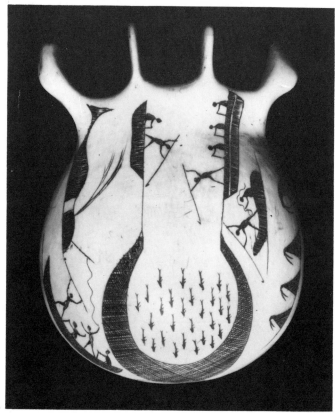

63 and 64 Walrus ivory ladle from Alaska, $4\frac{1}{4}$" x $4\frac{1}{4}$". Exterior, scrimshawed with scenes of drag netting salmon, walrus hunting and whaling. Interior, with scenes of caribou hunt, and shooting bears with bows and arrows. (Sotheby and Co, and the Museum für völkersunde, Munich)

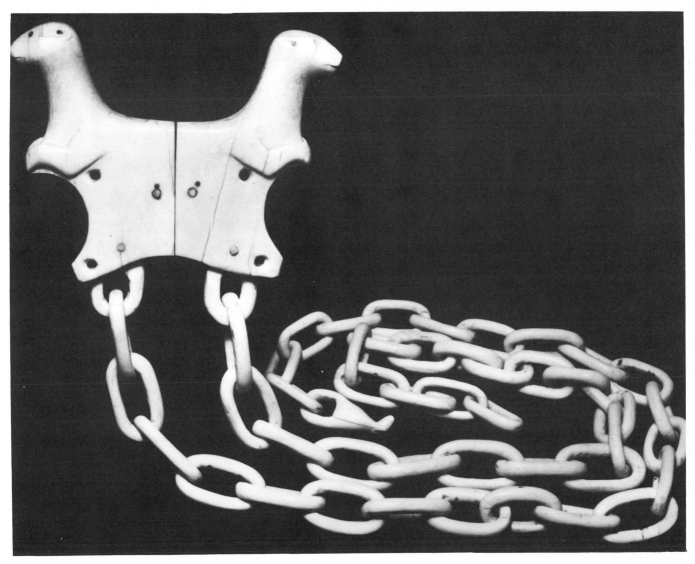

65 Boat rowlock and chain carved from walrus ivory, in the shape of two polar bears with eyes inlaid with blue glass beads and inlaid wooden nostrils (Sotheby and Co)

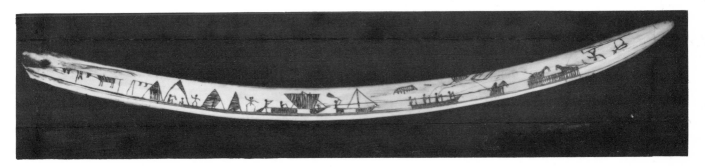

66 Walrus ivory bow drill from Alaska, with scrimshaw scenes of tents, boats and hunting, $15\frac{1}{4}$" long (Sotheby and Co)

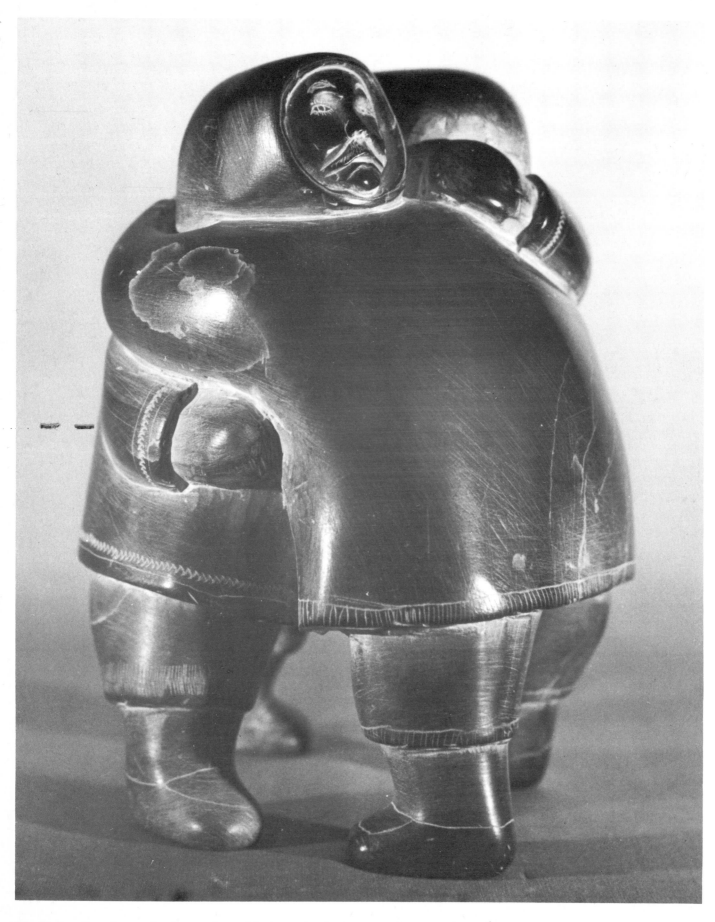

67 Modern Canadian carving in soapstone of two wrestlers by Napatchie, from Cape Dorset (Canadian Arctic Producers Ltd)